IMAGES
of America

SAN FRANCISCO'S
PACIFIC HEIGHTS AND PRESIDIO HEIGHTS

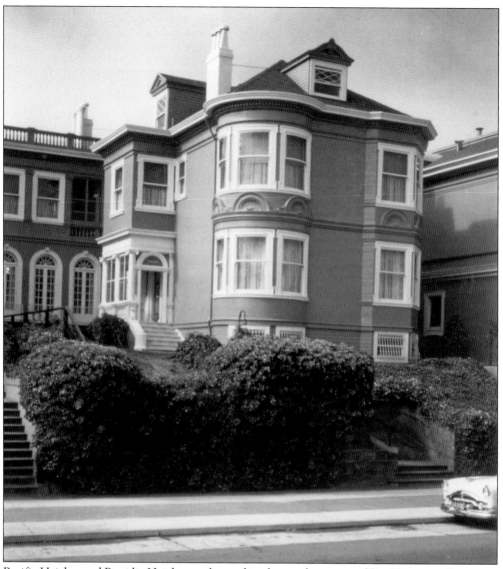

Pacific Heights and Presidio Heights are located in the northern part of San Francisco. From east to west, the Pacific Heights boundaries cover Van Ness Avenue to Presidio Avenue; from north to south, they cover Vallejo Street to California Street. From east to west, the Presidio Heights boundaries cover Presidio Avenue to Arguello Boulevard, and from north to south, Pacific Avenue to California Street. This gorgeous house on Clay Street between Spruce and Locust Streets is the family home of author Tricia O'Brien. She lived here with her parents, two brothers, three sisters, and many pets. (Courtesy of Proctor Jones Jr.)

ON THE COVER: Here are Mr. and Mrs. C. J. Colley and neighbors in front of their home at 3166 Washington Street right after the 1906 earthquake. They had no water for two weeks and had to use a wheelbarrow to transport fresh water home everyday. (Courtesy of David Parry.)

IMAGES
of America

SAN FRANCISCO'S
PACIFIC HEIGHTS AND
PRESIDIO HEIGHTS

Tricia O'Brien

ARCADIA
PUBLISHING

Published by Arcadia Publishing
Charleston SC, Chicago IL, Portsmouth NH, San Francisco CA

Printed in the United States of America

Library of Congress Catalog Card Number: 2008930855

For all general information contact Arcadia Publishing at:
Telephone 843-853-2070
Fax 843-853-0044
E-mail sales@arcadiapublishing.com
For customer service and orders:
Toll-Free 1-888-313-2665

Visit us on the Internet at www.arcadiapublishing.com

To my mom and dad

CONTENTS

ACKNOWLEDGMENTS

This book would not have been possible without the generosity of my family, friends, neighbors, and various organizations. I would like to thank my editor, John Poultney, for his time, patience, and encouragement.

Without photographs and stories, this book would not be possible, so I would like to thank the following people and organizations for letting me invade their lives: Adolphous and Emily Andrews, Mary Applegarth, Mary Ashe, Melissa and Patrick Barber, Paul Barry, Bill Beutner, Joe Beyer, Sarah Blanchard, Lisa Bloch, Nan Bouton, Robert W. Bowen, Al Breslauer, Lynn Bunim, Jeffrey Burns, Marc Calderon, Bob Chandler, Margaret Charnas, Courtney Clarkson, Lana Constantini, Dona Crowder, Celine Curran, Amanda Denz, Anita Jean Denz, Betsy Dohrman, Lynn Downey, Nancy Drapin, Penelope Duckworth, Delia Ehrlich, Anne Ellinwood, Erin Farrell, Charles Ferguson, Stacey Fleece, Charles Fracchia, John Garvey, Gail Goldyne, Joan Gordon, Catherine Grandi, Eric Grantz, Marilyn Hayes, Muriel Hebert, Kenneth High, Caroline Hume, Proctor Jones, Deanna Kaster, Kevin Kelly, Ann Kirk, Noel Kirshenbaum, Francine Kong, Lucy Hume Koukopoulos, Don Langley, Jane Lesh, Gerard Lespinette, Sandy Mateus, Jackson McElmell, Corinna Metcalf, Hank Minkey, Gladyne Mitchell, Michael "Mickey" Morris, Susan Smith Morris, Melissa Dong Mountain, Virginia Murillo, Jane Newhall, David Newman, Walter Newman, MaryPat Noeker, David Parry, Anne Paxton, Kate Qvale, Mark Ryser, Elizabeth ("Beth") Skrondal, Evy Speigelman, Nancy Svendson, Jack Tillmany, Paul Trimble, Louise Tuite, Anne Wachter, Sarah Lindsay Wong, Stephen Zellerbach, the Archdiocese of San Francisco, the Blood Centers of the Pacific, Boy Scout Troop 14, the Chicago Title Company, the First American Title Company, the San Francisco Architectural Heritage, the San Francisco Historical Society, the San Francisco Planning Department, and the Broadway Alumnae of the Sacred Heart board members.

I would like to extend a very special thank-you to Doug Johnson, who has been extremely patient and supportive, and my Simon, Sebastian, and Bailey.

INTRODUCTION

Pacific Heights and Presidio Heights have long fascinated and awed residents and visitors with its beauty, architecture, and stunning bay views. Using vintage photographs culled from individuals and various organizations, this book goes beyond just the beautiful facades of the mansions to provide a personal peek into everyday life in Pacific Heights and Presidio Heights.

It takes all kinds to make a neighborhood; these neighborhoods just happen to have a few more notables than most. Often the focus is on the architecture, which is stunning and unique, but there are numerous books about that topic already. Here you will see the architecture, but also get a personal glimpse of who lived here and why this place is special.

In this book, Pacific Heights is bordered by Van Ness Avenue on the east, Presidio Avenue on the west, Vallejo Street on the north, and California Street on the south sides. Presidio Heights' range is from Presidio Avenue on the east to Arguello Street on the west, Pacific Avenue on the north to California Street on the south sides.

For the most part, the neighborhood is residential, quiet, and private.

The neighborhoods are primarily made up of homes, but there are some parks, businesses, schools, and hospitals as well. This book shows homes that have been here since the mid- to late 1800s, as well as some buildings that no longer exist but were once part of the neighborhoods.

Once known as the outside lands and part of the Western Addition, Pacific Heights and Presidio Heights have evolved into San Francisco's most exclusive neighborhoods.

As the city expanded out from Yerba Buena cove, Pacific Heights used to be in what was called the Western Addition, according to early maps. In the 1850s, there was a flicker of interest in moving to these outlands. In the 1860s, the move west started and real development began, and in the 1870s through the 1880s, development really took off. It started as a middle-class neighborhood, but by the end of the 19th century, it had become an enclave for the upper-middle and upper class, and by the 20th century, this was much more defined.

The huge middle-class push over the slopes of Nob Hill into what is now Pacific Heights first centered on the eastern portion of the area, with grand mansions along Van Ness Avenue. Numerous parties were held along this corridor until April 18, 1906, when a major earthquake struck San Francisco and triggered a fire that burned a significant amount of the city. The fire line went down Van Ness Avenue, sending many residents fleeing from their homes. Many grand homes were destroyed in an effort to prevent the fire from spreading farther west.

After the 1906 earthquake and fire, many people from eastern neighborhoods moved farther west as a result of destroyed homes and the desire for more solid ground to live on. Maud Flood is a good example; her husband, James, promised her a house in a safe location, saying he would build her a house of marble on a hill of granite.

Available land in Presidio Heights and the addition of public transportation west into Pacific Heights also helped encourage growth into the neighborhood. The area was considered too far away for those working in the financial district downtown. Charles Fracchia, founder of the San Francisco Historical Society, believes that one of the great crimes of San Francisco history was the removal of cable cars from Pacific Heights.

Today in the eastern portion of Pacific Heights, moving east to west from Van Ness Avenue to Fillmore Street, one will see a mixture of architectural styles, with some remaining Victorian homes, while the streets farther west are considered more modern in comparison. The section of western Pacific Heights along Broadway Street between Divisadero and Lyon Streets is sometimes called the Gold Coast. This is a term that came out of Chicago; it is not a term most locals grew up with. It is probably called this because the most expensive homes in all of San Francisco can be found here.

Starting in the 1920s, downsizing started to become popular. This desire made way for the rise of luxury apartments and the demolishing of some homes in Pacific Heights. Downsizing often meant a one-level home as opposed to a multi-level house, but downsizing was not a change in lifestyle, entertaining, or dismissal of staff. The luxury apartments were quite large and stylish.

Considered old and no longer in fashion, many houses were divided after World War II as young single people began migrating to San Francisco, causing a significant rise in population.

Believe it or not, in the mid- to late 1970s, big houses were not in fashion; nobody wanted them. They were priced extremely low and still hard to sell.

At one time, the rags, bottles, and sacks cart came through the neighborhoods, the milkman delivered here three to four times a week, and veggie trucks driven mostly by Chinese came through selling fresh produce. Kids played kick-the-can in the street without worry of being run over by speeding vehicles.

Consulates from all over the world made Pacific Heights their home. World leaders and Hollywood celebrities have visited and still do. Business leaders were born here and still inhabit some of the homes. Even with all the movers and shakers, many residents were and are generally private people when it comes to family and home life.

One

PACIFIC HEIGHTS EAST

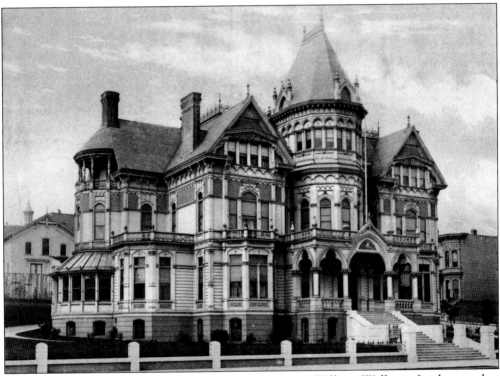

Originally, Aimee Crocker of Sacramento was to marry William Wallace after he won her hand in a game of dice. However, on the railway journey from Sacramento to San Francisco, Wallace let Aimee out of his sight for a few moments, and R. Porter Ashe, who had lost the dice game, somehow convinced Aimee to marry him instead. Her parents, Judge and Mrs. Edwin B. Crocker, were less than pleased, but they gave her this home on the corner of Van Ness Avenue and Washington Street, built by William Curlett and Walter J. Cuthbertson, as a wedding gift in 1882. The house was later sold to Walter Scott Hobart, an extremely wealthy mine owner. The house survived the 1906 earthquake and fire, but the family moved anyway. It was then used by the City of Paris department store, which had burned in the fire. In 1913, the structure was demolished to make way for a more modern building. (Courtesy of the Collection of the San Francisco Architectural Heritage.)

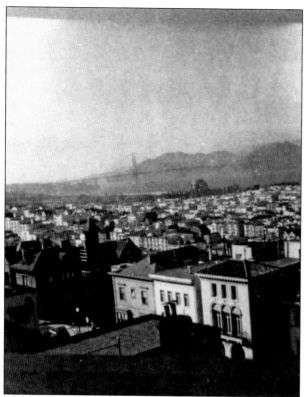

Pacific Heights is known for its amazing views. This view from 2222 Broadway Street, between Fillmore and Webster Streets looking toward the Golden Gate Bridge, is one example of why the views from Pacific Heights are so desirable. (Courtesy of Corinna Metcalf.)

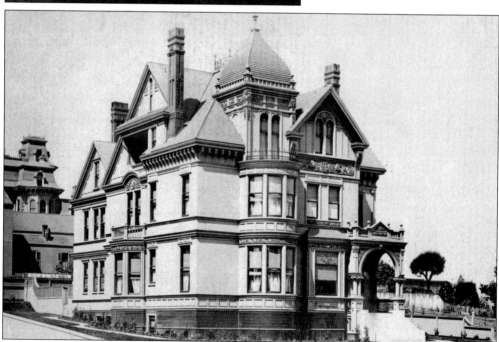

This home at 2001 Van Ness Avenue on the northwest corner of Jackson Street belonged to F. A. Frank and his wife. They accepted visitors on Thursdays and also owned a home in St. Helena. (Courtesy of the Collection of the San Francisco Architectural Heritage.)

In 1888, the house at 1630 Jackson Street near Van Ness Avenue was home to Henry E. Bothin and his wife, Ellen, when they were not at their country residence in Sausalito. George Percy and Frederick Hamilton were the architects. This house was destroyed the day of the 1906 earthquake to help create a fire line to contain the raging flames. (Courtesy of the Collection of the San Francisco Architectural Heritage.)

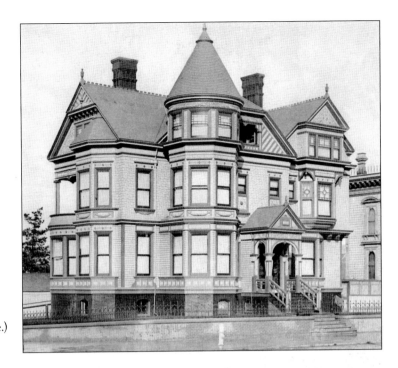

The White Cross Drug store, located at 2221 Van Ness Avenue on the corner of Pacific Avenue, has a sign claiming that "here you'll always get personal attention and what you ask for." The telephone number was Fillmore 6782. The building is still there, but it is now a restaurant. (Courtesy of Robert W. Bowen.)

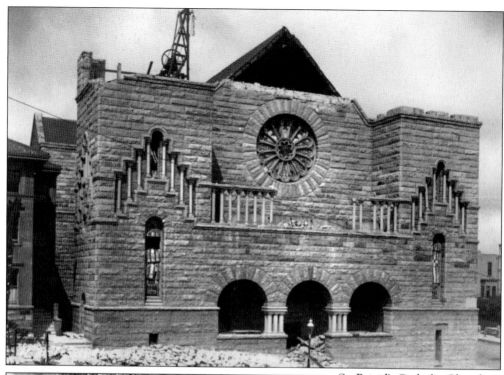

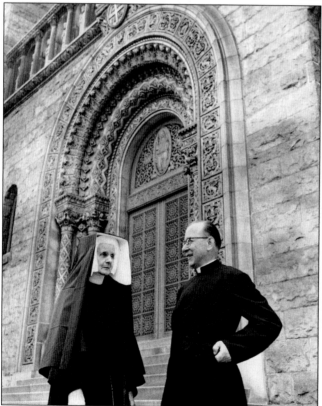

St. Brigid's Catholic Church (above), located on the corner of Van Ness Avenue and Broadway Street, suffered damage from the 1906 earthquake but was repaired and was able to reopen seven months later. St. Brigid's parish was founded in 1863. (Courtesy of the Archives of the Archdioceses of San Francisco.)

By 1959, the church had gone through several renovations. Here are Sister Stanislaus and Fr. James O'Connor in front of the ornate doors of St. Brigid's Church. (Courtesy of the Archives for the Archdioceses of San Francisco.)

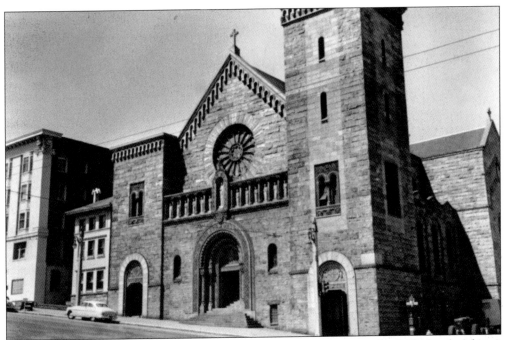

The original church was a simple, one-story structure with two rooms. In 1897, the church was demolished to make way for a new larger church. In 1900, the new cornerstone was laid, and in 1904, the new church made of old curbstones was dedicated. In 1947, the church was renovated and increased in size. (Courtesy of the Archives for the Archdioceses of San Francisco.)

On December 17, 1967, a Christmas musicale featuring the Stanley Noonan singers, along with the Cy Trobbe orchestra, was performed in St. Brigid's auditorium. The performance started at 8:00 p.m., and a donation of $3 per ticket was requested. (Courtesy of the Archives for the Archdioceses of San Francisco.)

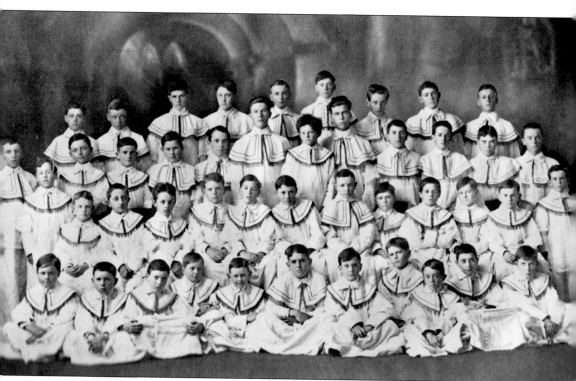

St. Brigid's Catholic Church celebrated its golden jubilee in 1913. Shown here are the student singers who participated in the ceremonies. (Courtesy of the Archives for the Archdioceses of San Francisco.)

At one time, St. Brigid's had an elementary and a high school. St. Brigid's Parochial School opened in 1888. The teachers were nuns from the Sisters of Charity of the Blessed Virgin Mary, an Irish order founded in Dublin in 1831. In 1928, a new concrete building was erected to replace the old wooden schoolhouse. (Courtesy of the Archives for the Archdioceses of San Francisco.)

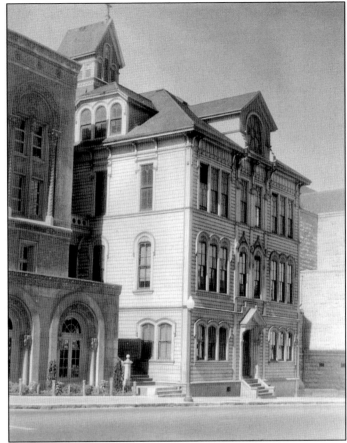

The high school is pictured below. St. Brigid's High School ceased to exist in 1953. (Courtesy of the Archives for the Archdioceses of San Francisco.)

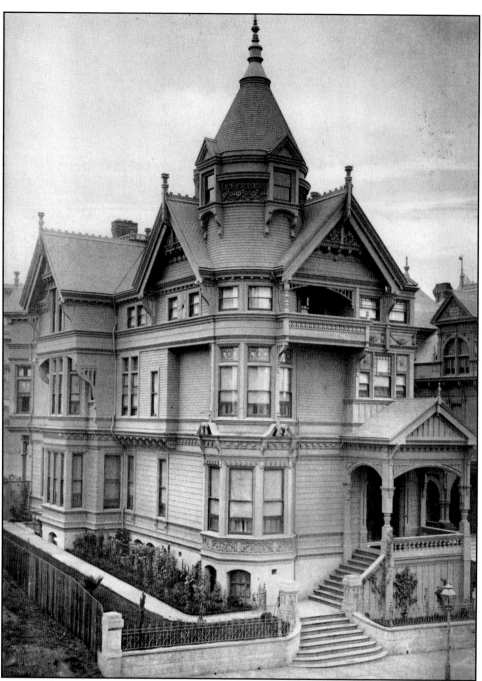

William Lilienthal and his brother Abraham moved from Bavaria to New York, and in October 1868, William arrived in San Francisco. He worked in the grocery business for Leopold Loupe and Kalman Haas. In 1886, he had architect Peter R. Schmidt and builders McCann and Biddell construct this house. The left side of the home was expanded in 1905 to make room for a parlor on the main level and bigger bedrooms upstairs. Three generations of the Haas and Lilienthal family lived here until 1972. Now it is a museum. (Courtesy of the Collection of the San Francisco Architectural Heritage.)

Jane Swinerton (Ophuls) rides her bike along Franklin Street with the Haas Lilienthal house in the background in the 1920s. Jane lived at 1921 Sacramento Street but frequently visited her friend Frances Lilienthal (Stein) at 2007 Franklin Street. Jane's parents were prominent builders who were know for their top quality and safety. (Courtesy of the Collection of the San Francisco Architectural Heritage.)

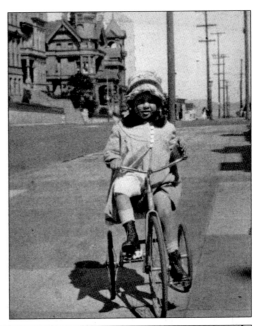

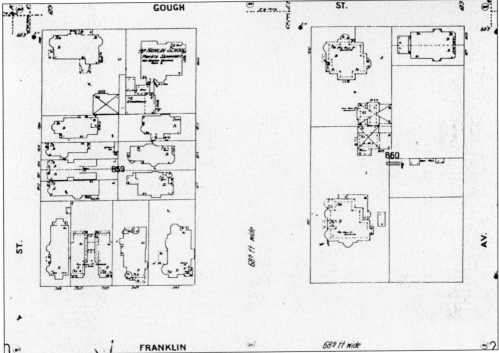

This map shows a different perspective of the couple blocks in Pacific Heights on Pacific Avenue between Franklin and Gough Streets. The Hamlin School was located on the more populated top left side of the map. Also in the area, Ludwig and Carrie Fleishhacker Schwabacher lived at 2000 Gough Street. Ludwig managed Crown Paper Company, later known as Crown Zellerbach. After the 1906 earthquake, Albert and James Schwabacher stored their inventory from Schwabacher-Frey at 2000 Gough Street, enabling the store to survive. (Courtesy of the Collection of the San Francisco Architectural Heritage.)

When the 1906 earthquake and fire destroyed the headquarters of Wells Fargo Nevada National Bank, 2020 Jackson Street became the temporary headquarters for the company. The signs hanging from the house are, from left to right, Emanuel S. Heller and Frank H. Powers, Attorneys at Law, today known as Heller, Ehrman, White, and McAuliffe; Union Trust Company of San Francisco; and Wells Fargo Nevada National Bank. Architect Julius E. Krafft designed this house in 1902 for Clara, the daughter of Isaias William Hellman, when she married attorney general Emanuel Heller, who was from a pioneer family. (Courtesy of a private collection.)

The home at 1998 Jackson Street is on the northeast corner of its intersection with Laguna Street. It was the Sanford Goldstein residence. A house built in the 1940s currently sits at this location. (Courtesy of David Parry.)

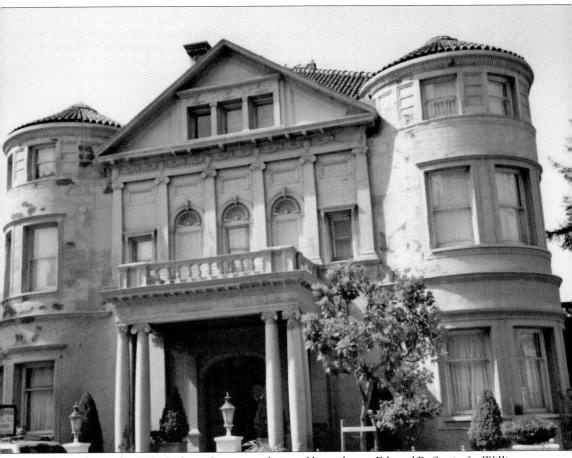

The home located at 2090 Jackson Street was designed by architect Edward R. Swain for William Frank Whittier, a wholesale hardware and lumber mogul, which allowed for the extraordinary wood inside. The framework is steel covered with sandstone. Sandstone crumbles easily, much to the dismay of the owners. At one time, the house was the consulate for Nazi Germany; Fritz Weideman, the last consulate general, lowered the ceilings and put in faux-plaster ceilings, then left just before war was declared. Mortimer Adler, a great philosopher and writer, also lived in the mansion and had his institute of philosophical studies centered here. It was also where he left his wife to marry the secretary, with a departing statement that when marriage comes in the door, love goes out the window. In the 1950s, the San Francisco Historical Society purchased the home for approximately $50,000 and used the building for their headquarters. In 1980, they took down the faux ceilings and found spectacular ceilings. It has since been sold and is used as a residence. (Courtesy of a private collection.)

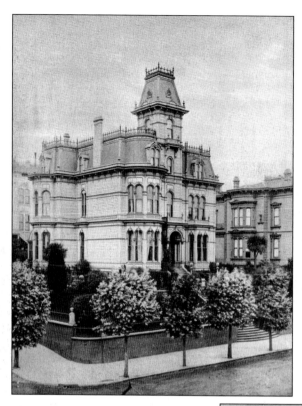

In 1887, this was the home of Nathaniel P. Cole and his wife, Elizabeth. It was located at 1801 Franklin Street on its northwest corner at Sacramento Street. Nathaniel was a merchant, specializing in furniture. He contracted architects Wright and Sanders to build this house. The Coles received guests on Mondays. (Courtesy of the Collection of the San Francisco Architectural Heritage.)

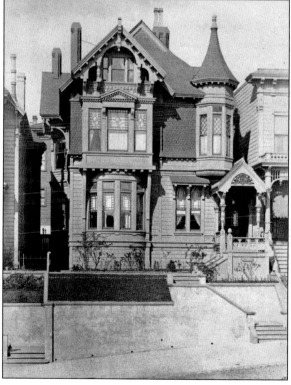

The structure located at 2202 California Street was home to Dr. Robert I. Bowie in 1888. Architects Albert Pissis and William Moore designed the house. They were known for only using the best and most expensive materials. (Courtesy of the Collection of the San Francisco Architectural Heritage.)

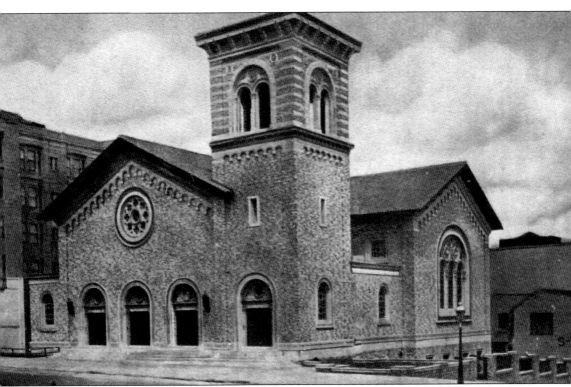

The First Church of Christ Scientist, located on the corner of Franklin and California Streets, was built in 1911. The structure is an example of ecclesiastical architecture designed by Edgar A. Mathews, a Bay Area native. The exterior uses a unique pattern and palette of brick, and the interior is a clever combination of colors, utilizing both winter and summer hues. The organ is a W. W. Kimball, No. 6742, that was installed in 1923 and is cared for by the well-known conservator Edward Stout. The members have Bible lessons that are studied fully every week, then read on Sunday. There is a reader's desk rather than an altar, and the members read from either the King James Version of the Bible or Science and Health by Mary Baker Eddy. There is also a Sunday school, and testimonial meetings are held on Wednesday evenings with short readings and testimonials of healing. (Courtesy of Robert W. Bowen.)

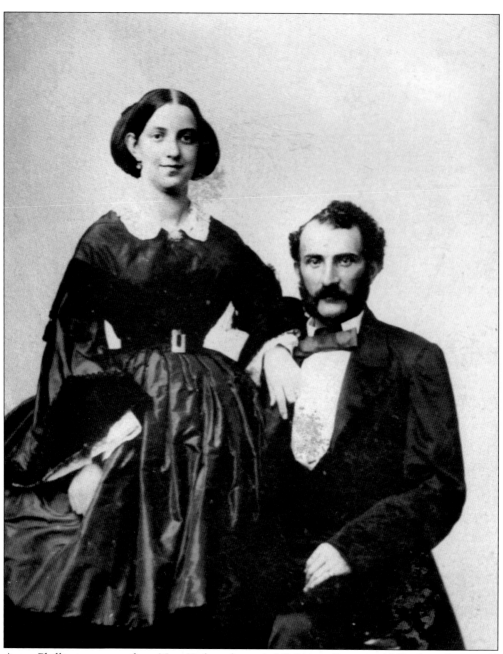

Anne Phillips came out from New York and married Solomon Sweet in 1860 when she was 16 years old. Solomon Sweet came to California to seek his fortune in the Gold Rush. Solomon founded S. Sweet and Company in the central valley. (Courtesy of Evy Speigelman.)

After achieving great success with S. Sweet and Company, which supplied farmers in the central valley with equipment and supplies, Solomon Sweet purchased this house at 2230 Pacific Avenue to provide his wife, Anne, with a city home, complete with proper facilities. They had five former Chinese railroad laborers working for them. Herbert and Mortimer Fleishhacker were among the many friends and family who came over from Europe to stay in this house until they had saved enough to go out on their own. Two young men, Herbert and Mortimer Fleishhacker, sold sewing equipment door-to-door and eventually went on to become successful bankers and entrepreneurs. (Courtesy of Evy Speigelman.)

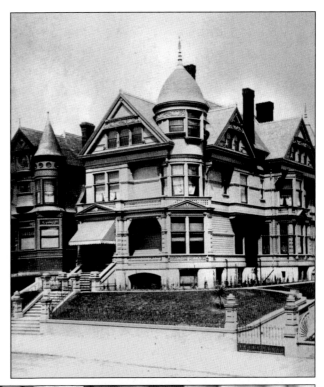

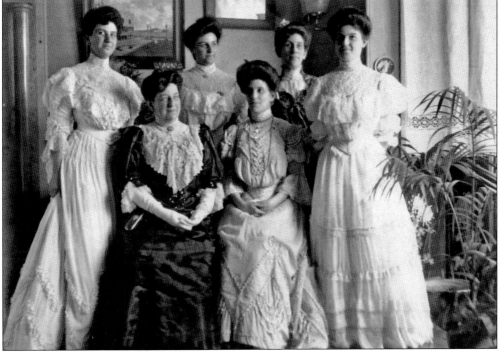

Annie Solomon is surrounded by her daughters as they prepare for Ida Sweet's wedding to Victor Uhlman. From left to right are (seated) Annie and Ida; (standing) Bertha Joseph, Mabel Baer, Louise Bettelheim, and Estelle Sweet. (Courtesy of Evy Speigelman.)

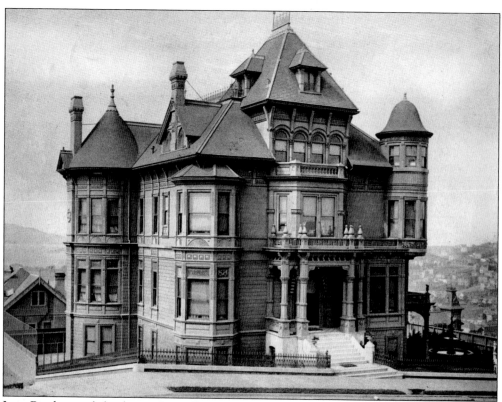

Jean Boyd owned this home, located at 2020 Washington Street on the northwest corner of Octavia Street, before it was torn down at the same time that several other neighboring homes were moved. Then George Applegarth created a magnificent mansion for sugar magnate Adolf Spreckles and his wife, Alma, at this location. (Courtesy of the Collection of the San Francisco Architectural Heritage.)

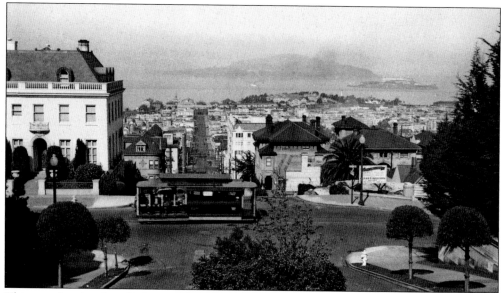

This was the view from Jackson and Octavia Streets in 1940. (Courtesy of Jack Tillmany.)

From left to right, John Rosekrans, Dorothy Munn, Cary Grant, and Georgette "Dodie" Rosekrans enjoy themselves at one of the many parties they attended around the world. Dorothy Munn is the daughter of Adolf and Alma Spreckles, and heir to a sugar company fortune. John Rosekrans, a toy company executive, is also the grandson of Adolf and Alma Spreckles. Dodie Rosekrans, John's wife, is the daughter of Michael Naify, who owned a chain of movie theaters. (Courtesy of Louise Tuite.)

The structure, located at 1966 Pacific Avenue, was the home of Abraham Stern, nephew of Levi Strauss. After the death of Levi Strauss in 1902, his four nephews—Jacob, Sigmund, Louis, and Abraham Stern—inherited the family firm, Levi Strauss and Company. After the earthquake and fire of 1906, Abraham's home was used as a temporary headquarters until the business was moved to a building in Oakland, and then south of Market Street, while the construction of a new warehouse and headquarters on 98 Battery Street was under way. This photograph shows the company sign above the doorway. (Courtesy Levi Strauss and Company Archives.)

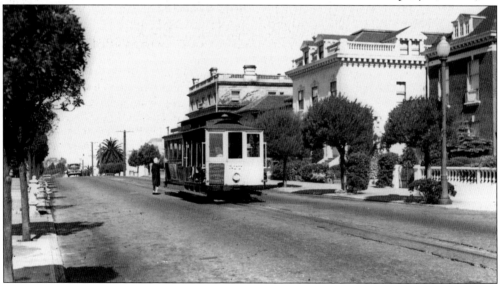

In 1944, cable cars traveled down Washington Street. This photograph was taken just east of Laguna Street near the Irwin Mansion. (Courtesy of Jack Tillmany.)

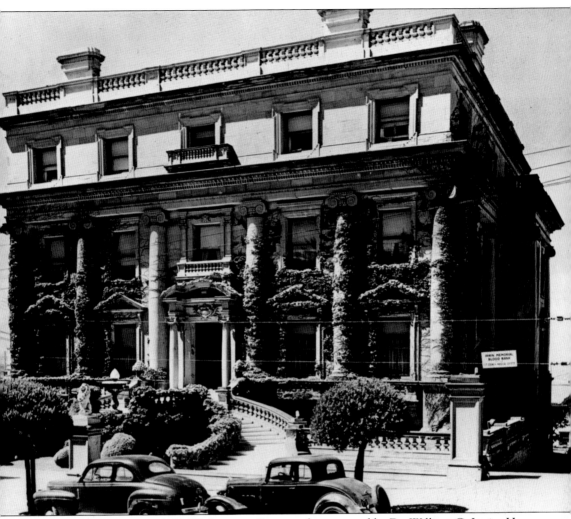

This mansion once sat at 2190 Washington Street and was owned by Dr. William G. Irwin. He donated the mansion to the San Francisco Medical Society, who used it as their headquarters from January 1926 through March 1955. The physicians of San Francisco made a promise to the citizens that no patient would be without an adequate supply of blood. In June 1941, the first nonprofit community blood bank in the nation opened for business in the basement of this house. To donate and store blood was a revolutionary concept. Look closely to notice the sign on the right side; it says "Irwin Memorial Blood Bank SF County Medical Society." The house was eventually sold in mid-1953 after sitting on the market for two years without a single buyer coming forward. When the board reviewed the potential buyer's offer, they decided that there was probably $15,000 to $30,000 worth of work needed before a new building could even be started, so they voted to accept a price of $135,000 plus an extended lease so the medical society could stay a little longer. The blood center had expanded its reach and required a larger facility; in April 1955, they moved to Masonic and Turk Streets. In 1960, the mansion was torn down to make room for an apartment building. (Courtesy of the Blood Centers of the Pacific.)

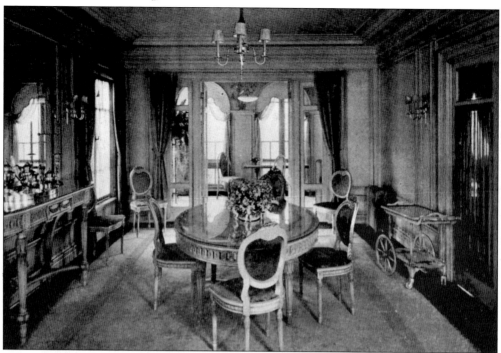

This apartment, located at 1810 Jackson Street, was the residence of George W. Kleiser. This was one of eight apartments in a building designed by Conrad Alfred Meussdorffer in 1917. Kleiser started out as a dentist before partnering with Walter Foster to create Foster and Kleiser, the biggest outdoor advertising sign company on the West Coast. Above is a glimpse of the dining room, and below is the living room. (Courtesy of David Parry.)

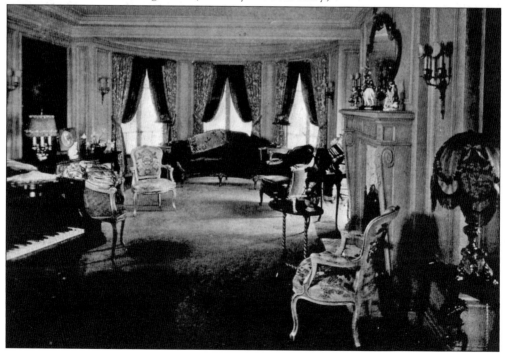

Built in 1932, the building located at 2170 Jackson Street was an apartment house of five rental apartments, one on each floor, until the 1950s, when it became a co-op. Charles Harney, the contractor who built Candlestick Park, lived in the penthouse and is believed to have built this building. (Courtesy of the Fleishhacker family collection.)

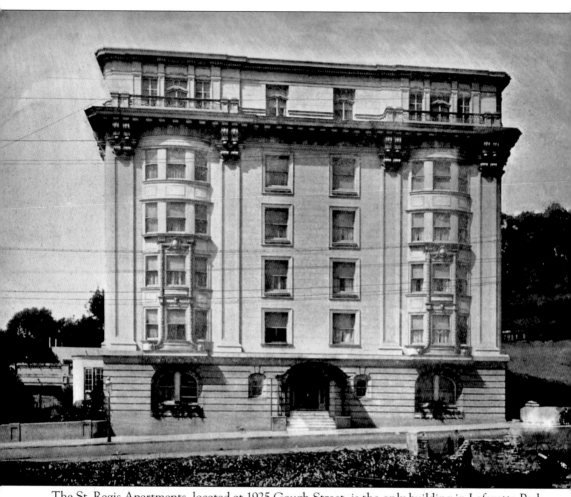

The St. Regis Apartments, located at 1925 Gough Street, is the only building in Lafayette Park. The city had ordered parks to be built in the western portion of town, but the project did not get going on time. Once it was under way, attorney Samuel W. Holladay, whose home was on Clay and Octavia Streets, claimed squatters rights, saying the land had never been dedicated as a park, and the courts agreed, allowing him the use of the open space on Clay Street from Octavia to Gough Streets. Eventually, the city managed to take some of his land away anyway, leaving him with the portion now known as 1925 Gough Street at Clay Street. The building was developed by Alexander William Wilson, who hired apartment architect Conrad Alfred Meussdorffer. There are two apartments on each floor. The building is actually owned by a corporation, whose shareholders have included Wilson, Edmond Coblentz, and other well-known business executives. (Courtesy of David Parry.)

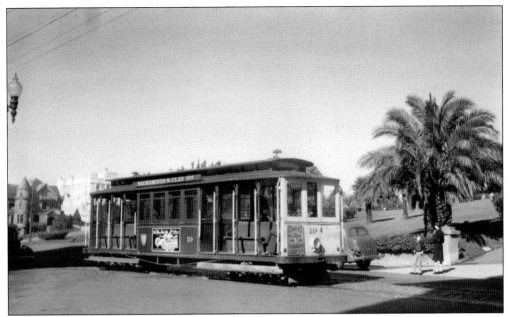

In 1942, cable cars still ran down Sacramento Street, shown here in front of Lafayette Park. (Courtesy of Paul Trimble.)

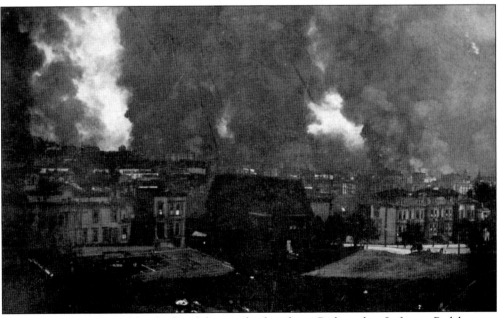

The 1906 earthquake and fire displaced thousands of residents. Parks such as Lafayette Park became campgrounds for those forced from their homes. Many stood helpless and watched as much of the eastern part of San Francisco burned. Van Ness Avenue served as a fire line, and Lafayette Park was only a couple of blocks to the west. (Courtesy of Robert W. Bowen.)

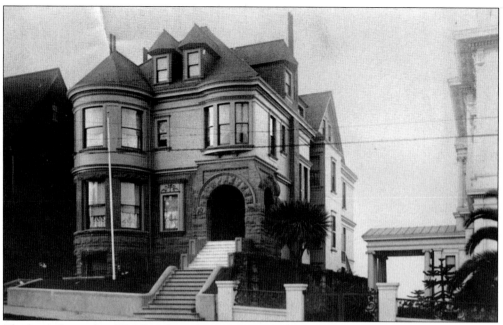

The home located at 2124 Broadway Street, near Webster Street, was once owned by Adolf and Annie Son. They raised their four children—Charles, Ida, Helen, and Blanche—in this house. It remained in the family until the Depression. Several owners had the home until it was eventually torn down. Currently, the Hamlin School owns the property, and the school is located next door. (Courtesy of Ann Kirk.)

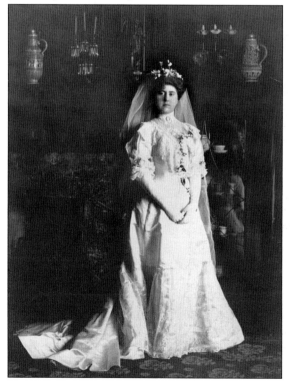

On January 28, 1906, Ida Son married Julius Mayer. The wedding, with 106 guests, was held at 2124 Broadway Street. Charles S. Wheeler was the caterer, and the total bill was $515. The family loved having guests, and the ballroom table and the monogrammed service easily accommodated 48 guests. (Courtesy of Ann Kirk.)

Charles Son, the only son and eldest child of Adolf and Annie Son, ran for attorney general of California. His sisters Helen and Blanche are shown here. The sisters spent most of their time doing charity work and attending the theater. (Courtesy of Ann Kirk.)

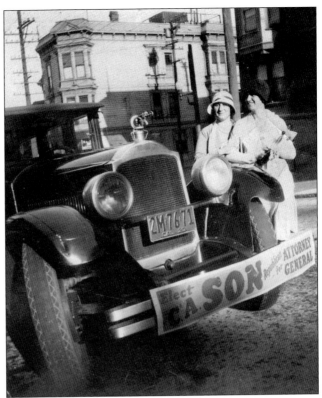

Sitting in front of the house is Barbara Mayer, daughter of Ida, Annie and Adolf's eldest daughter. Barbara was born in 1906 at 2124 Broadway Street and grew up there. (Courtesy of Ann Kirk.)

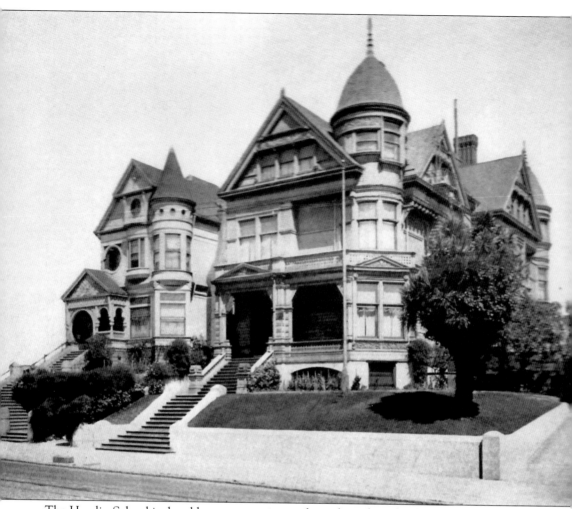

The Hamlin School is the oldest nonsectarian, independent, day school for girls in the western United States. Sarah Dix Hamlin took over in 1896 and turned the school into a strong academic environment for women. In 1907, the school was moved to this mansion, located at 2230 Pacific Avenue. In 1927, the school then moved to 2120 Broadway Street, where it was known as Stanwood Hall. A second building, McKinne Hall, was erected in 1961 at 2129 Vallejo Street, with an additional floor added in 1967. The third building, the Jenny May Hooker science laboratory, is a two-room building located in the middle of the block between the other two buildings. The two larger buildings were named for the owner and headmistress from 1927 to 1946, Cornelia McKinne Stanwood. The small building was named for her sister, Lila McKinne, who inherited the building in 1946 and, in 1957, donated it to the school. (Courtesy of the Hamlin School.)

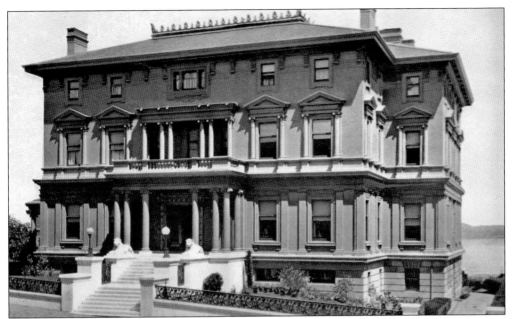

In 1901, James Leary Flood contracted architect Julius Krafft to build him a glorious three-story Italian Baroque Revival mansion at 2120 Broadway Street. His sister Jennie's home on Nob Hill was destroyed by fire after the 1906 earthquake, so she moved to this house. "Miss Jennie" stayed in the home until 1924, when she donated the house to the University of California and moved to the Fairmont Hotel. (Courtesy of the Hamlin School.)

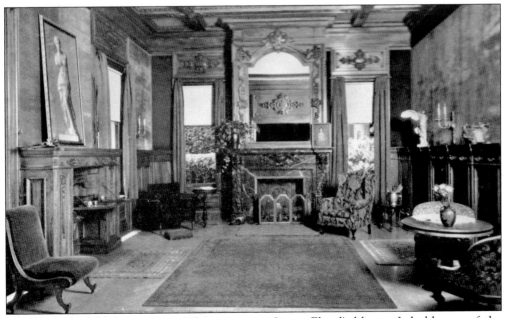

The house had 24 large rooms. This room was James Flood's library. It holds one of the 13 fireplaces in the house. Hand-rubbed walnut was used to create the panels. (Courtesy of the Hamlin School.)

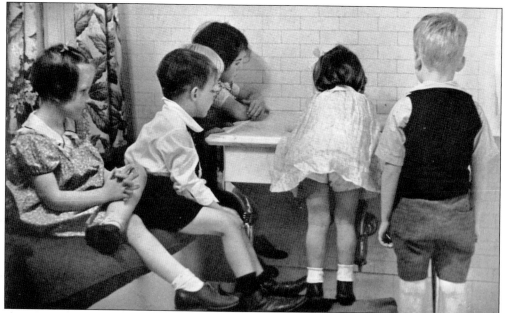

At one time, the Hamlin School hosted boarders and allowed boys to attend. Here is a group of young coeds cleaning up after a busy project. (Courtesy of the Hamlin School.)

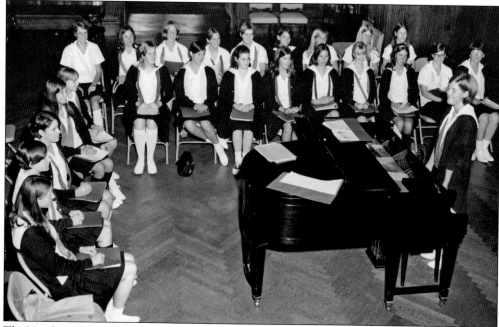

The Hamlin School Glee Club, led by Mrs. Richard Miles, is rehearsing with newly elected rehearsal assistant Fredrica ("Ricka") Jacobsen in 1967. From left to right are (first row) Tracey Howard, Mikel Nahas, Teddy Bloom, Ann Simon, Francis Shell, Sara Maule, Cathy Sachs, Michelle Fontaine, and Betsy Dun; (seated clockwise in the second row) Lynn McDermott, Sue Bullock, Alice Fay, Pam Greenbach, Sandra Higbie, Karne Schmidt, Sharon Smith, Bea Borroughs, Nancy Hoffner, Lygia Kasprzyk, Esther Bullard, Liz Bullard, Leslie Finke, and Christine Blanchard. Absent are Tricia Parsons and Terry Boucke. (Courtesy of the Hamlin School.)

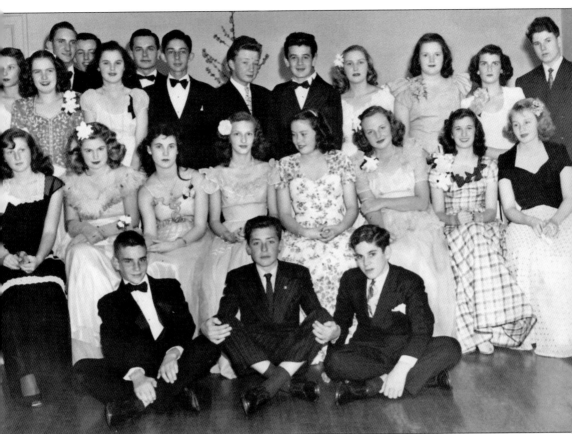

The Hamlin School hosted dances for the students, most of whom lived in Pacific Heights or Presidio Heights. From left to right are (first row) Dave Harrigan, Stanley Coup, and Richard Branston; (second row) Jackie Friend, Anne Marsiano, Nancy Bartlett, Patsy Younger, Eva Black, Audrey Frakes, Delia Fleishhacker, and Corrine Cook; (third row) Nan S?, Joan Coffer, Barb Hayes, Tracey Cummings, Alex Politear, Ralph ?, Pat Beauchamp, Jane Ramsey, Judy Blood, and Lytle Horton; (fourth row) Bob McKeaver, Roger ?, and Pat Ryan. (Courtesy of the Fleishhacker family collection.)

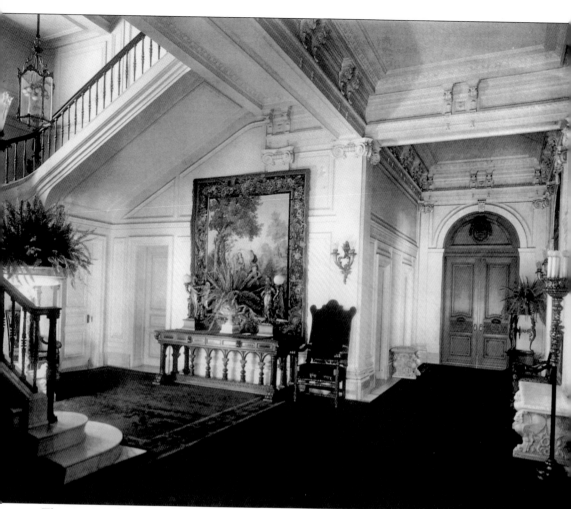

This neoclassical house, located at 2200 Broadway Street, was the city/winter home of Joseph and Edith Donohoe Grant when they were not at their Burlingame house or one of their ranches. It was designed by New York architects Philip Hiss and H. Hobart Weeks and was built out of stone and brick by the Mahoney brothers, who were also the contractors for the St. Francis Hotel. The home has five levels in the back and three in the front, high ceilings, marble floors, and paneled walls. Built in 1867, it is pictured here in 1915, and much remains the same to this day, except that the furniture has been changed to accommodate the students of the Convent of the Sacred Heart Elementary School, who now occupy the house. (Courtesy of the Schools of the Sacred Heart.)

This magnificent garden behind the Grant house once graced the hill on Webster Street just below Broadway Street, all the way down to Vallejo Street. (Courtesy of the Schools of the Sacred Heart.)

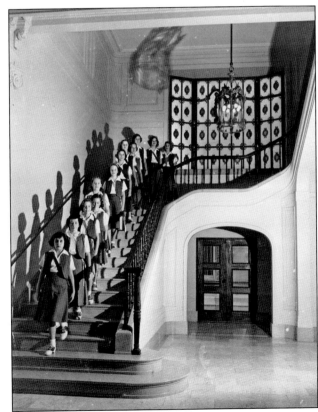

This is the same staircase shown on the opposite page, but in 1950, students from the new junior school descend rather than a family. (Courtesy of the Schools of the Sacred Heart.)

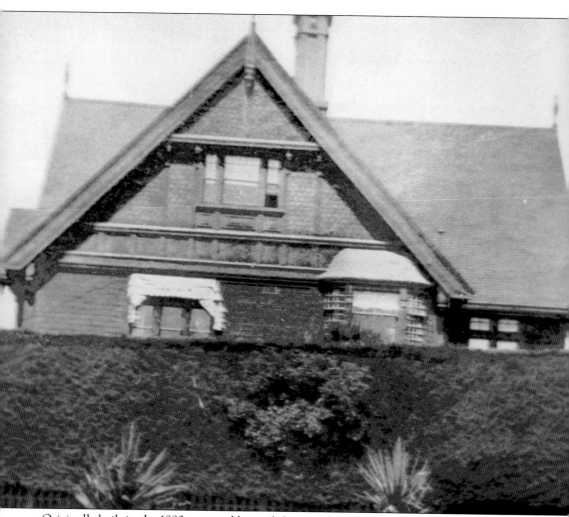

Originally built in the 1880s as a wedding gift from William F. Babcock, a shipping magnate, to his daughter Alice and her new husband, Dr. Charles Bingham, this house now sits at 2828 Vallejo Street. In 1911, James Flood offered to purchase the land and move the home to a place of Alice Bingham's choosing, all so he could build his new home at 2222 Broadway Street. Later the Rheems, of Rheem and Company, owned the house and were known to throw marvelous parties. One in particular had two orchestras, 800 roses, and 200 guests. After Mr. Rheems died, his widow was not allowed to sell the home. In 1957, Adolphus and Emily Andrews purchased the home from the heirs. The house looked rather bleak when they first viewed it, so Emily told her husband he could only buy it if he would build a kitchen. Architects Steiner, Lo, and Porter got to work and found an enormous Wolfe range that lived in the front hall for awhile. The Andrews wondered how it would fit through the kitchen door, and when they expressed their concern, the architects looked wounded and said not to worry. When the great range-moving day arrived, it did not fit through the door and needed to be disassembled. The range is still in the kitchen today. Only two changes have been made to the facade of the home: upstairs the bedroom windows in front were changed from sash to swing-out windows, and downstairs in the dining room, the plain window was altered to French doors and a patio was added with the intent of eating outside. (Courtesy of Jane Lesh.)

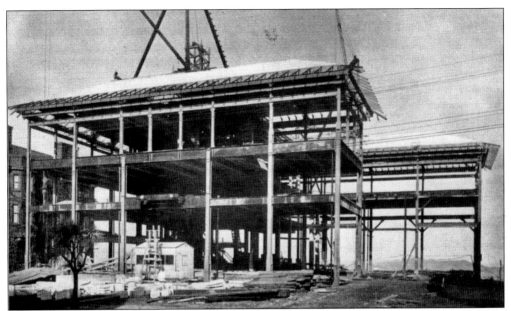

After the 1906 earthquake and fire, many were afraid to rebuild, including Maud Flood. James Flood told his wife he would buy the safest lot so she could come back to San Francisco. He saw how well the Grant house had withstood the earthquake, so he thought the lot next door would be perfect; all he had to do was figure out how to move the house that stood there. This photograph shows the construction of 2222 Broadway Street in December 1912. (Courtesy of the Schools of the Sacred Heart.)

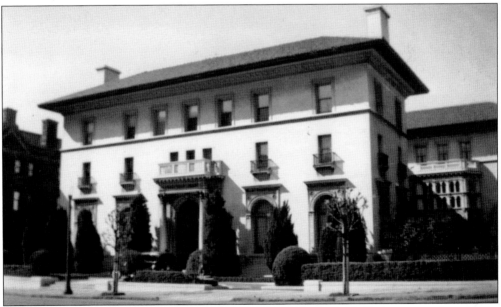

As promised, James Flood built his wife, Maud, a house of marble on a hill of granite so she could be safe from earthquakes and have a first-class view of the 1915 Panama Pacific International Exposition. The architects were Walter Bliss and William Faville. The interior is classic Beaux-Arts; not many residences look like this one. The best materials money could buy were used, including the rarest marble from Africa in Maud Flood's bedroom. (Courtesy of the Schools of the Sacred Heart.)

41

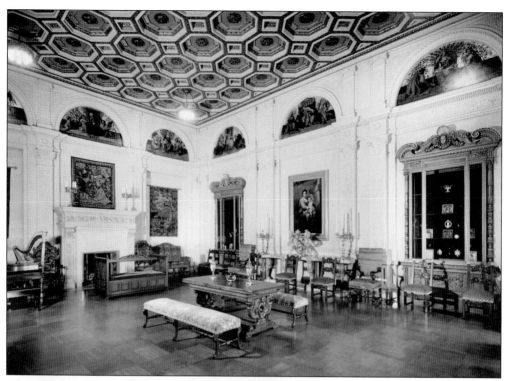

Maud Flood had a vision for each of the rooms in her house. This room (above) was a parlor with exquisite detail. The ceiling alone is a work of art, with each octagon specially crafted with five layers; the center is gold, surrounded by blue, followed by rose and gold lines, then gold balls and colored semi-circled designs, surrounded by perfectly white walls. (Courtesy of the Schools of the Sacred Heart.)

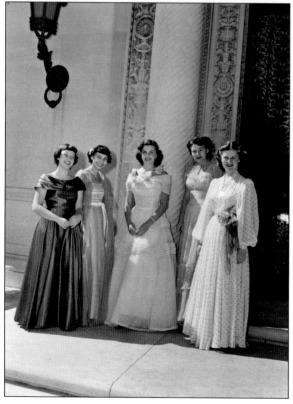

Convent of the Sacred Heart High School students (from left to right) Colette Nicole, Dianne Goldman, Ann Lista, Marilyn Sanchez-Corea, and Sharon Chadbourne wait in front of the doors of the Flood mansion in 1951. (Courtesy of the Schools of the Sacred Heart.)

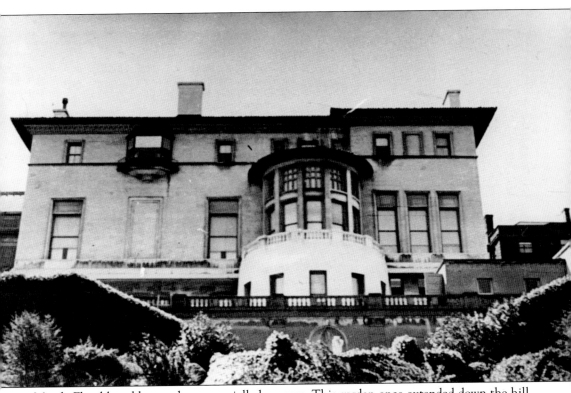

Maude Flood loved her gardens, especially her roses. This garden once extended down the hill from Broadway Street to Vallejo Street. After James passed away, Maud did not want to live there by herself. Her dream was to have the house used for education, so she donated the house to the Religious of the Sacred Heart. She first asked Reverend Mother Hill if she would mind if Maud kept the house until her son was married. When the day came to turn the house over to the nuns, Maud graciously offered the Reverend Mother the key and a rose from her gardens. (Courtesy of the Schools of the Sacred Heart.)

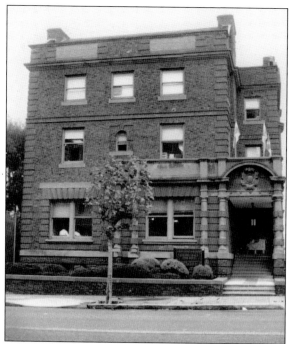

This home, located at 2252 Broadway Street, was known as the Hammond house, named after its lumber and railroad magnate owner, Andrew Hammond. It was designed by architect Julius E. Krafft. Frank DeBellis later owned the house. In the 1950s, DeBellis had a radio program on KEAR called Good Music. DeBellis intended to donate the mansion to the American Foundation for Italian Culture, Inc.; however, he was slighted by the Italian general consul at the inaugural party, which sparked a feud. Today this building is home to the Stuart Hall for Boys elementary school. (Courtesy of the Schools of the Sacred Heart.)

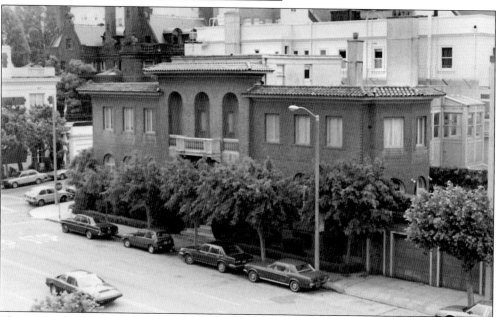

The Herbst House, located at 2201 Broadway Street, pulls from numerous architectural influences to create a style all its own. Florence and Samuel Lowenstein, who changed their name to Lowe during World War I, hired G. Albert Lansburgh to design the house. They lived here for 15 years, and in the early 1930s, they moved to the Fairmont Hotel and sold their home to John M. Grant, no relation to the Grants across the street. This Grant was a Scotsman and a banker. In the fall of 1985, the house became part of the Schools of the Sacred Heart. It is called the Herbst House in honor of Maurice H. Herbst, who established the foundation that purchased the house for the school. (Courtesy of the Schools of the Sacred Heart.)

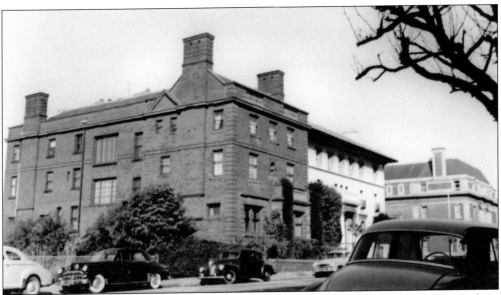

Today three former private residences are part of the Schools of the Sacred Heart. Shown here from left to right are Stuart Hall for Boys elementary school, Convent of the Sacred Heart High School, and Convent of the Sacred Heart girls' elementary school. (Courtesy of the Schools of the Sacred Heart.)

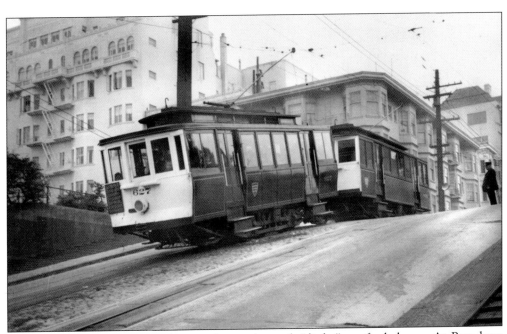

The Fillmore Street streetcar line used a single truck "dinky" car for balance. At Broadway Street, the cars were hooked to a cable, allowing the car going downhill to counterbalance the car coming uphill between Broadway and Green Streets. The cars were powered with electric motors drawing current from the overhead trolley wires. The Fillmore Street counterbalance line was limited to 26 passengers because of the 25-percent grade of the street. Later lines had to be rerouted to avoid the steep grade. (Courtesy of Paul Trimble.)

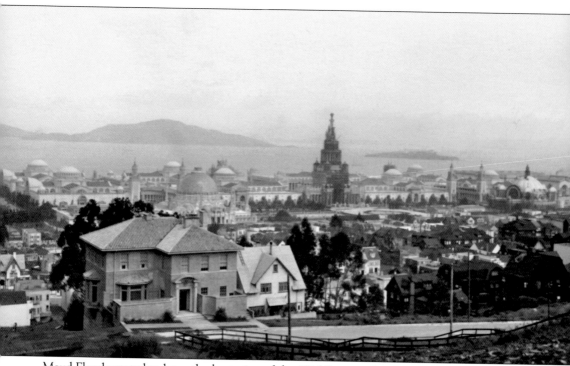

Maud Flood wanted to have the best view of the 1915 Panama Pacific International Exposition from her house on Broadway Street. This photograph was taken a few streets away from her home but is still an example of the stunning views that captured the attention of those who flocked to Pacific Heights. (Courtesy of David Parry.)

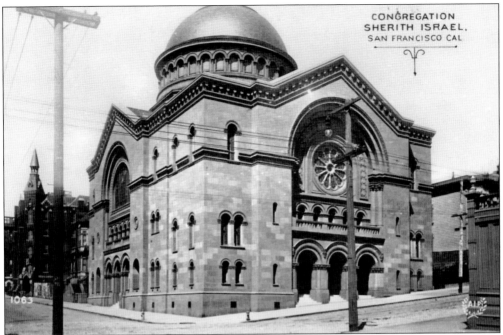

Congregation Sherith Israel was founded in 1851, first on Stockton Street, then on Post and Taylors Streets, and now on Webster and California Streets. The dynamic Rabbi Jacob Nieto served this community from 1893 to 1930. The building, designed by Albert Pissis, survived the 1906 earthquake and fire. While rebuilding, courts and civic functions took place here, including one of San Francisco's most well-known political corruption trials in which Abe Ruef, Mayor Eugene Schmitz, and the entire board of supervisors were tried for extortion. (Courtesy of Robert W. Bowen.)

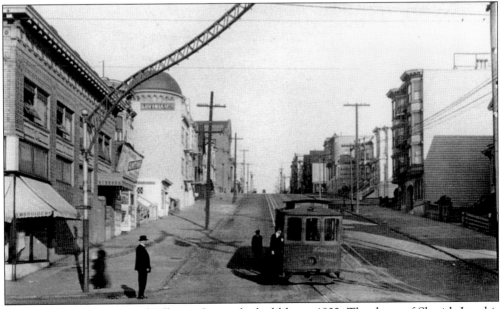

This is what California and Fillmore Streets looked like in 1922. The dome of Sherith Israel is visible on the left-hand side. (Courtesy of Jack Tillmany.)

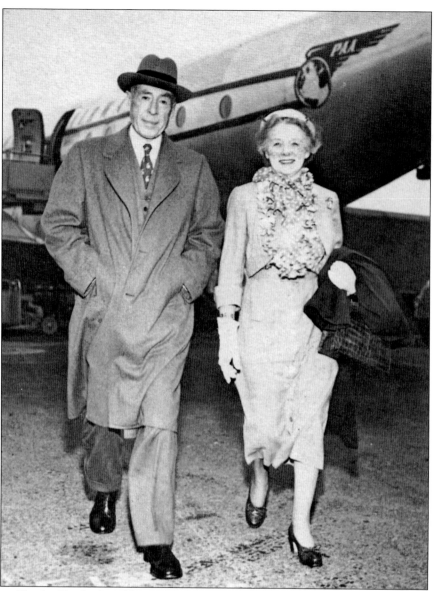

Here are Charles Kendrick and his wife, Kathryn, returning home from one of their many trips abroad. Charles was a major force in San Francisco as a businessman and philanthropist. He was an attorney, developer, and business owner, including owning the Schlage Lock Company, and was involved in the community. As president of the board of regents at the University of San Francisco (USF), he donated the law school and helped grow the school into a larger institution. Being a lover of music, opera in particular, Charles went to the mayor to ask if he would consider having an opera house that would be dedicated as a war memorial on the piece of land available for development across from city hall. Charles was a major benefactor, and he was on the committee to establish the War Memorial Opera House and the adjacent Veterans Building complex. He and Helen Crocker Russell were also major forces in founding the city's first Modern Art Museum in the Veterans Building adjacent to the War Memorial Opera House. Charles and Kathryn had six children; they lived in a historic house at Pierce and Vallejo Streets. Eventually, they moved to Washington Street near Gough Street. (Courtesy of a private collection.)

Two

PACIFIC HEIGHTS WEST

One of San Francisco's oldest movie theaters, the Clay Theatre, located at 2261 Fillmore Street, was built by the Naify brothers in 1910. It was the first nickelodeon house in town. Herbert Rosener turned the theater into the Clay International in 1935 and showcased international films, an example of which is shown in this photograph. In the 1970s, new owners, the Surf Theatres group, took over, and many controversial films were shown while Mel Novikoff was in charge. In 1991, Landmark took over and still maintains the single-screen movie house. (Courtesy of Jack Tillmany.)

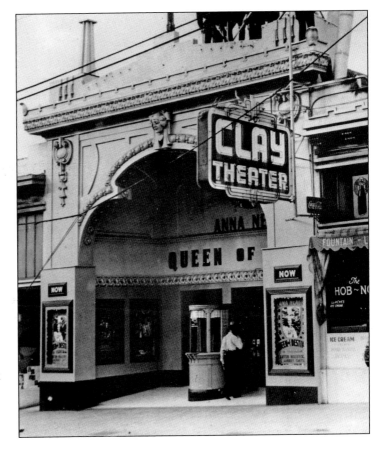

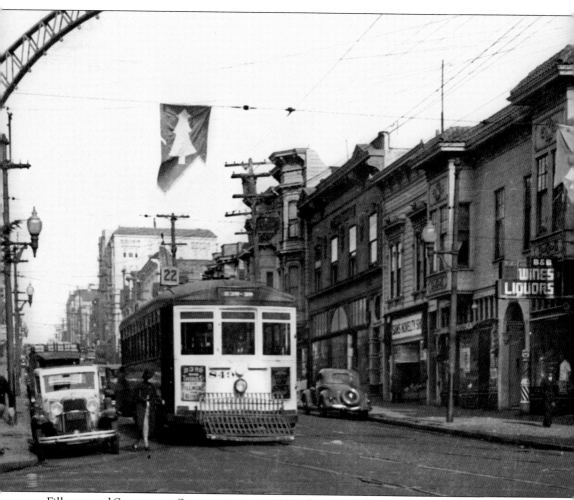

Fillmore and Sacramento Streets are seen in 1936 when the 22-line stop on this block took people to the Clay Theatre, Sam's Novelty Shop, the barbershop, or the B&B wine and liquor store. (Courtesy of Jack Tillmany.)

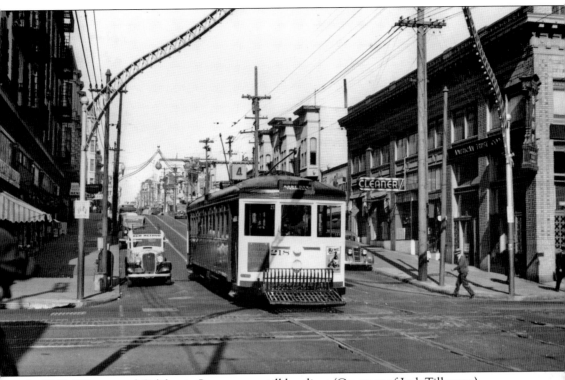

In 1940, Fillmore and California Streets were still bustling. (Courtesy of Jack Tillmany.)

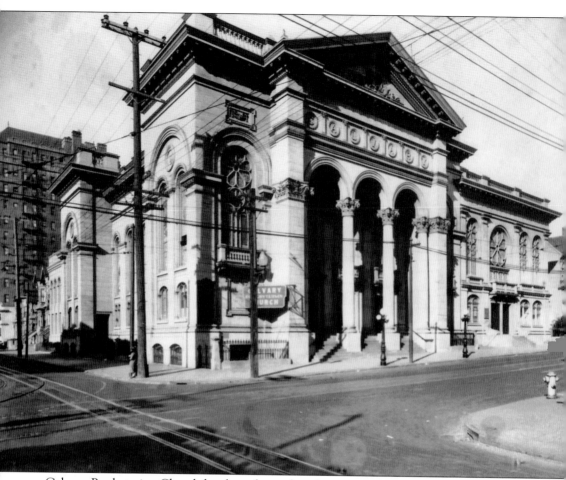

Calvary Presbyterian Church has been located at the corner of Fillmore and Jackson Streets since 1902, when this photograph was taken. The church survived the 1906 earthquake without significant damage and was used by many community groups, including becoming the temporary home of Temple Emanu-el, St. Luke's and Old First Churches, and the Superior Court. Founded in 1854, the building was first located on Bush Street, between Montgomery and Sansome Streets. In 1868, the congregation moved to a new building located at the corner of Powell and Geary Streets (where the St. Francis Hotel is now located). As the residential population migrated west, the church followed, taking most of the Union Square structure with them, including more than one million bricks, the pews, balcony supports, and a pipe organ. The first worship service at the Fillmore location was on Thanksgiving in 1902. The sanctuary has city and national landmark status. (Courtesy of Calvary Presbyterian Church.)

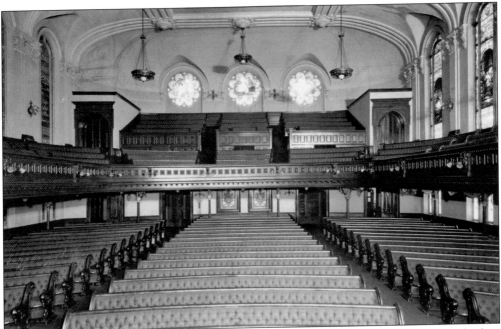

The pews, balcony supports, and most of the woodwork are original fixtures from the church when it was on Union Square. The stained-glass windows above and below the balconies depict stories from the Old and New Testaments, and survived the 1906 earthquake. Portions of the interior have been remodeled since this *c.* 1926 photograph. (Courtesy of Calvary Presbyterian Church.)

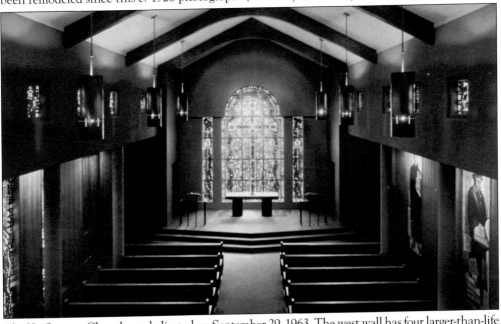

The Kit Stewart Chapel was dedicated on September 29, 1963. The west wall has four larger-than-life frescoes of Reformation leaders Martin Luther, John Calvin, John Knox, and Huldreich Zwingli that were created by Lucienne Bloch, a student of Diego Rivera. The east side has 1-inch-thick stained-glass windows representing the Gospel writers. The stained-glass window facing Jackson Street is dominated by the Celtic cross. (Courtesy of Calvary Presbyterian Church.)

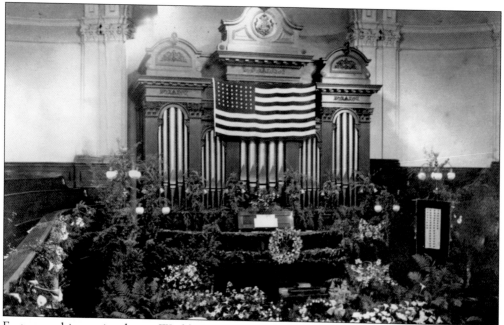

Easter worship service during World War I featured a special banner honoring members of the church who were fighting for their country, with each star representing a serviceman. Two notable features no longer in the church are the organ and the light fixtures decorated with Easter flowers. In 1928, the old organ was moved to St. Mary's College in Moraga, having been replaced by a much larger instrument. (Courtesy of Calvary Presbyterian Church.)

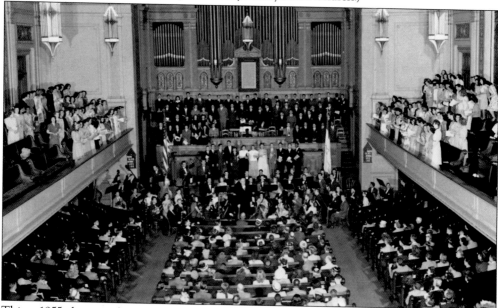

This *c.* 1955 photograph is from a performance by the San Francisco Bach Choir. Standing in the center is Waldemar Jacobsen, founder and director of this choir. At the time, he was also Calvary's director of music. The San Francisco Bach Choir continues to regularly give performances at Calvary, as do many other community choruses and the Calvary Chancel Choir. (Courtesy of Calvary Presbyterian Church.)

This photograph of the first class of the Calvary Nursery School was taken in the basement of the Calvary Presbyterian Church in 1956–1957. The school is still serving the community today as a play-based developmentally appropriate learning environment. Pictured from left to right are (first row) David Levin, Peter Miley, Katie Angstadt, Deke Tripp, Lewis Pain, Gardy Mein, Bruce Simon, Patricia Parsons, and Henni Adriaansa; (second row) Campbell Bean, Stephen Black, Louis Howie, Lindsay Wheeler, Stephen Truzzolino, Robert Davis, Lisa Luttgens, Bobby Feigenbaum, and Michelle Dimond; (third row) Kevin Vincent, Jay Monson, Derek Tracy, Sandy Volkman, Molly Pfau, Charles Callender, Joe Thompson, and Warren Cox. (Courtesy of Calvary Nursery School.)

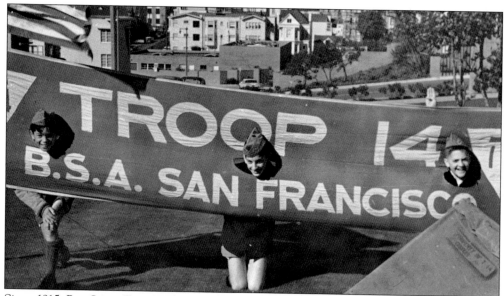

Since 1915, Boy Scout Troop 14 has called Calvary Presbyterian Church its home and sponsor, making it the oldest continuously sponsored Boy Scout troop in San Francisco. Raymond G. Hanson, who was also superintendent of the Calvary Presbyterian Church Sunday school, was the first Scout executive, and Homer Bemis, one of the teachers, became the Scoutmaster. (Courtesy of Troop 14.)

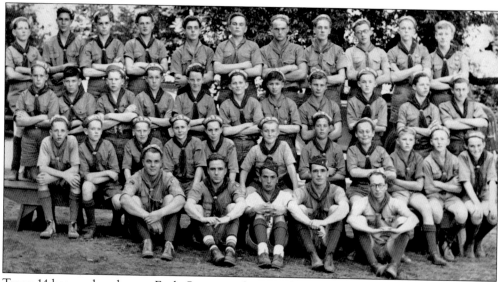

Troop 14 has produced many Eagle Scouts, and its members have gone on to become leaders in their fields and community. A few notables include Supreme Court justice Stephen Breyer, Charles Breyer, Bill Coblentz, Bob Haas, Don Fisher, Robert Fisher, Richard Goldman, and Damon Raike. In many cases, the sons and grandsons of members have joined the troop to carry on the tradition. Shown here from left to right are Scouts (first row) Byrne, Malloy, Anino, Davis, and Bush; (second row) Bent, Trowbridge, Fay, Williams, Dickson, Hueter, Heller, Cashin, Delahanty, Hueter, and Dunne; (third row) Spiegl, Unna, Stein, Middleton, Lynch, Van Nuys, Coblentz, Beaver, Kelly, Applegarth, and Levy; (fourth row) Hegman, Alanson, Boardman, Eggleston, Centurion, Dolman, Peterson, Lalanne, Goldman, Kern, and Hueter. (Courtesy of Troop 14.)

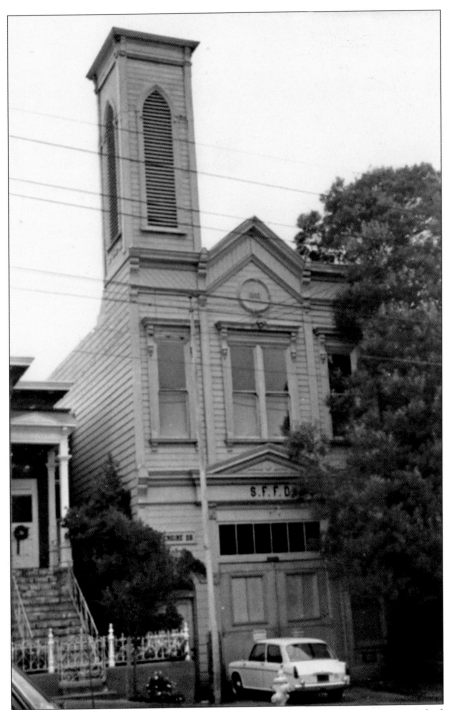

The building, located at 3022 Washington Street, was originally one of San Francisco's firehouses for Engine Company No. 23. Built in 1893 by Berhardt E. Henricksen, it ceased being a working firehouse in 1964 and became a private residence. Former governor Jerry Brown and designer John Dickinson are among the private owners of this house. (Courtesy of the San Francisco Fire Department.)

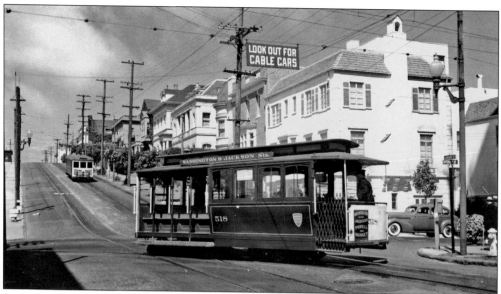

In 1940, cable cars still ran along Jackson Street at Steiner Street. (Courtesy of Jack Tillmany.)

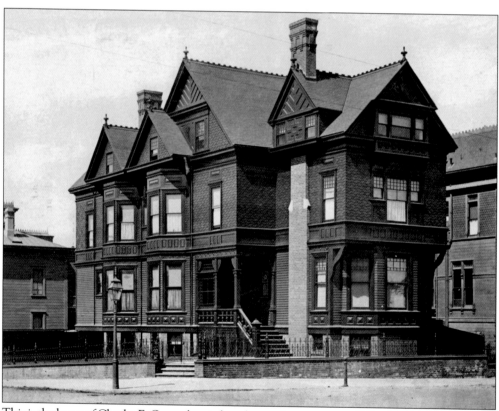

This is the home of Charles E. Green, located on the northwest corner of Fillmore and Pacific Streets, in 1888. Green was the secretary of the Pacific Union Club in 1901–1902. The Greens received guests on Fridays. (Courtesy of the Collection of the San Francisco Architectural Heritage.)

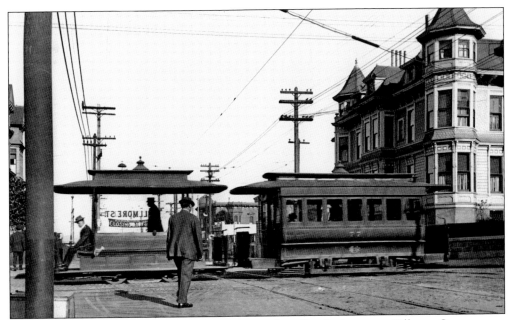

Long ago, in 1916, when public transportation ran along Pacific Avenue at Fillmore Street, many in Pacific Heights enjoyed a leisurely ride to work. A pampered pony also had the luxury of a special arrangement back home. Two neighborhood boys used to play kick-the-can on Broadway Street, many blocks from their home near Pacific and Baker Streets. One of the boys would take his pony along on their adventures, but by the end of the day, the pony was tired and refused to give the boys a ride home, so the boys made an arrangement with one of the conductors, and the tired pony was taken home in one of the cars. (Courtesy of Jack Tillmany.)

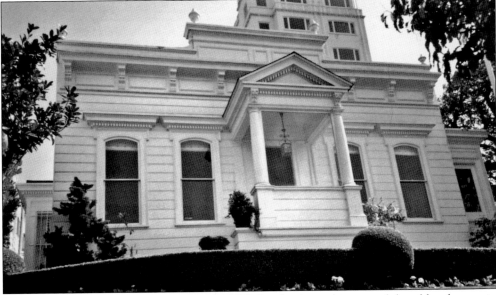

Built in the 1850s as a dairy farm house, 2475 Pacific Avenue is one of the oldest homes in Pacific Heights. It is a simple house that shows how the neighborhood was not always a fancy residential neighborhood. John Leale, a well-known ferry boat captain, purchased the house in 1883. (Courtesy of a private collection.)

Janet Louise Choynski Fleishhacker was born and raised in San Francisco and received her education abroad in Italy and France, where she became fluent in both French and Italian. In 1928, after graduating from the Hamlin School, she married Mortimer Fleishhacker. In 1937, they built the William Wurster House, shown here, at 2600 Pacific Avenue on the corner of Pierce Street. Janet was extremely involved in the community: she was head of the National Council of Campfire Girls, served as president of the board of trustees for the University of San Francisco, and was part of the League of Women Voters, the Children's Theater Association, the International Visitors' Center, the Salesian Boys Club, the Italo-American Society, the Red Cross, and many other committees and organizations. During World War II, she worked for the Red Cross and also served a three-year term on the Defense Advisory Committee on Women in the Services (DACOWITS). To top if off, she was always on the best-dressed list. Janet and Mortimer traveled the world together. She died on September 12, 1978, at the age of 78. (Courtesy of the Fleishhacker family collection.)

Mortimer Fleishhacker Jr. was born and raised in San Francisco and graduated from the University of California at Berkeley. He served in the U.S. Navy during World War II and was stationed in the South Pacific. Later Fleishhacker was involved in city planning through SPUR (San Francisco Urban Planning and Research) and was the chairman of the San Francisco Planning Commission under Mayor Joseph Alioto. He helped found and was the first chair of KQED public television and was an auctioneer on its annual fund-raiser for many years. He was also the president of Mount Zion Hospital, served on the board of the Asia Foundation, was the chairman of the 20th anniversary of the San Francisco Founding of the United Nations Committee, and was active in the United Way as chair of the Social Planning Committee, as well as other organizations too numerous to mention. Along with Cyril Magnin and Mel Swig, he helped bring the American Conservatory Theatre (ACT) to San Francisco. (Courtesy of the Fleishhacker family collection.)

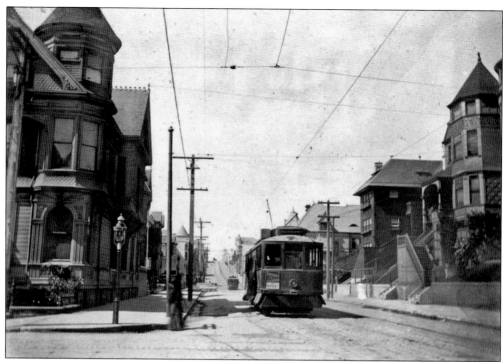

This block of Jackson Street near Divisadero Street featured several houses designed by architect Adolf C. Lutgens for his clients Charles and Caroline Wingerter, who were real estate investors. This photograph was taken in 1910; the homes were divided into multiunit buildings in the 1920s, as were many homes during this period. (Courtesy of Jack Tillmany.)

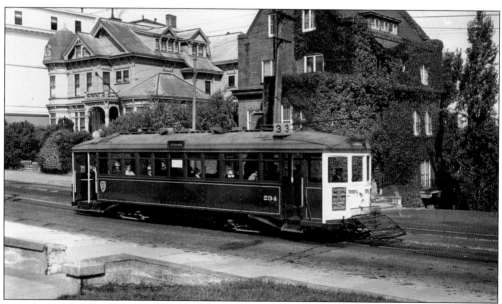

Jackson and Pierce Streets are shown here in 1937. (Courtesy of Jack Tillmany.)

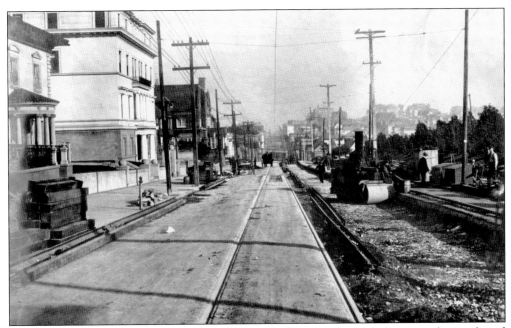

In July 1906, this was the view on Jackson Street looking east at Scott Street at the north end of Alta Plaza park. Workers already have half of the street ready for the new cable car lines. (Courtesy of Paul Trimble.)

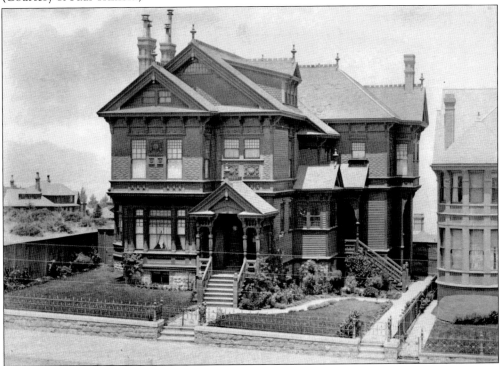

This home, located at 2610 Jackson Street, was the home of Mr. and Mrs. George W. Bowers in 1888. Architects George W. Percy and Frederick F. Hamilton designed the house. (Courtesy of the Collection of the San Francisco Architectural Heritage.)

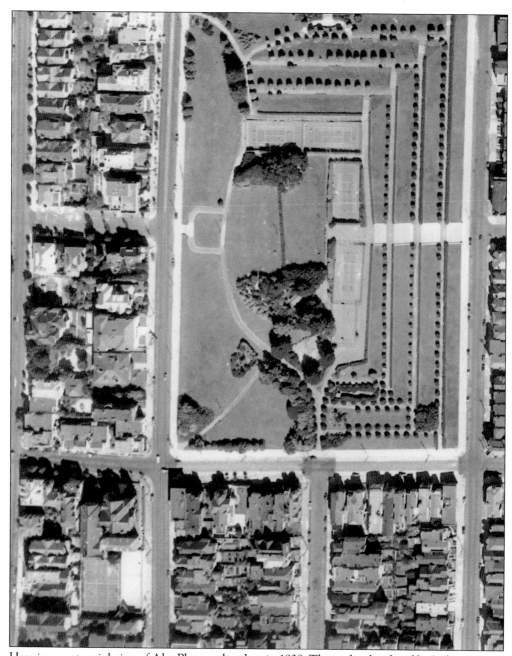

Here is a great aerial view of Alta Plaza park, taken in 1938. The park is bordered by Jackson Street on the north side, Clay Street on the south side, Scott Street on the west side, and Steiner Street on the east side. It is a popular place for families, dog walkers, tennis players, and sunbathers to spend a few minutes or the entire day. (Courtesy of Dona Crowder.)

This house, located on the corner of Pierce and Clay Streets, has been home to the Christ Episcopal Church, Sei Ko Kai since 1952. In June 1895, Nippon Sei Ko Kai of Japan founded the first Japanese Christian mission of the Anglican Communion in America to minister to new immigrants, as well as to help them find jobs and homes and adjust to their new life. In 1902, the Episcopal Church took notice and recognized it as an organized mission of the diocese. The church called many locations home until settling into this house. (Courtesy of Christ Episcopal Church, Sei Ko Kai.)

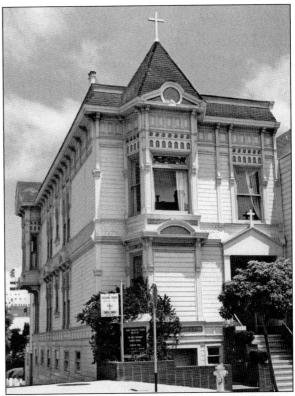

These people are part of the oldest Japanese congregation in the area. This photograph was taken on Easter Sunday in 1977. (Courtesy of Christ Episcopal Church, Sei Ko Kai.)

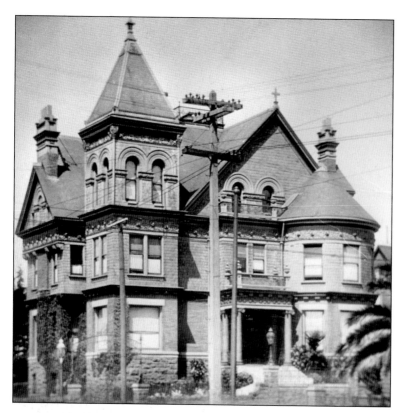

Built in 1894, this brick-and-stone structure was the home of Albert Gallatin, a member of a pioneer family. (Courtesy of the Schools of the Sacred Heart.)

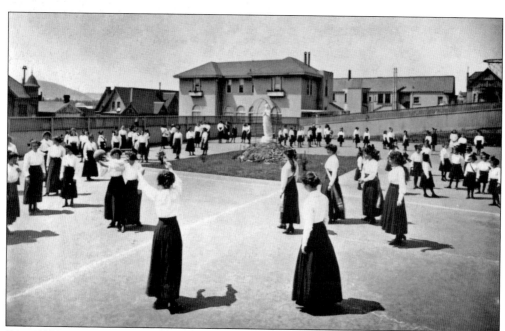

From 1909 to 1940, Convent of the Sacred Heart School for girls was located on Jackson and Scott Streets. It was later torn down to make way for the Town School for Boys. (Courtesy of the Schools of the Sacred Heart.)

This is the school chapel on the Jackson Street property. It was on school grounds, but it was a separate building from the school building. (Courtesy of the Schools of the Sacred Heart.)

The photograph below shows Jackson Street looking east from the corner of Divisadero Street. The billboards are advertising products and services such as "Geo. H. Kahn Optician 1232 Van Ness Ave. bt. Sutter & Post Sts. 'He Fits The Eye'," Kodak Agency Developing and Printing, Turkish Delight cigarettes (10 for 10¢), and White House Toys. Albert Gallatin's home is visible just beyond the billboards and empty lot. (Courtesy of Paul Trimble.)

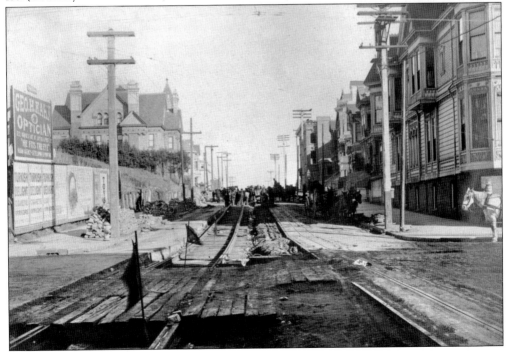

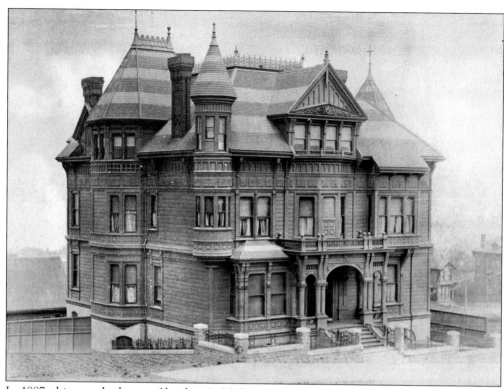

In 1887, this was the home of banker A. N. Drown. It was located on the northeast corner of Jackson and Pierce Streets. The architects were William Curlett and Walter J. Cuthbertson. (Courtesy of the Collection of the San Francisco Architectural Heritage.)

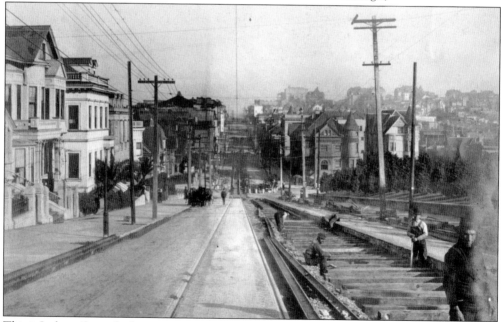

This is Jackson Street looking east at Pierce Street in December 1906. The Drown house is visible at the end of the park. (Photograph by Harry Mentz; courtesy of Paul Trimble.)

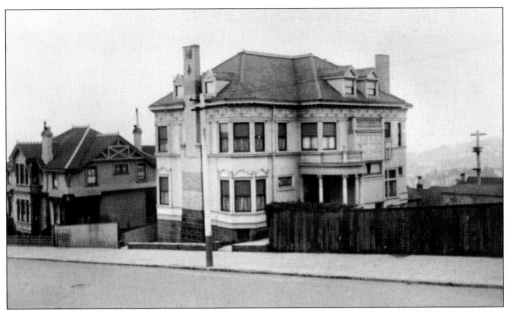

This is what 2504 Scott Street looked like when it was first built in the early 1900s. Today it is still a lovely home, but it appears to have been turned to face the street and pulled back a little so it sits farther from the curb. (Courtesy of a private collection.)

Thomas Church designed the gardens for 2504 Scott Street. This is the original sketch he made for the trellis study commissioned by the Bellis family. Church was an expert at combining the flow of the house to function with the garden to almost create another room. (Courtesy of a private collection.)

Hillwood Academic Day School teaches students from kindergarten through eighth grade. The desks in this photograph, taken in May 1964, are still in place and are used by the students. (Courtesy of Hillwood Academic Day School.)

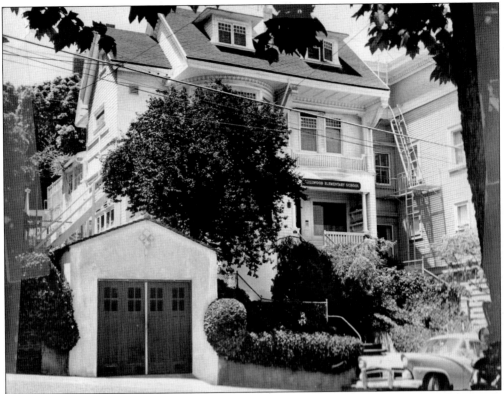

Hillwood Academic Day School, located at 2521 Scott Street, was founded in 1949 by Mary J. Libra. Her family continues to run the school. In 1956, the Hillwood school merged with camp Hillwood, which has been next to Muir Woods since 1890, providing a year-round outdoor recreational program. The house was originally owned by the Gunn family. (Courtesy of Hillwood Academic Day School.)

The school takes pride in educating their students in a family atmosphere to help them grow both academically and socially. (Courtesy of Hillwood Academic Day School.)

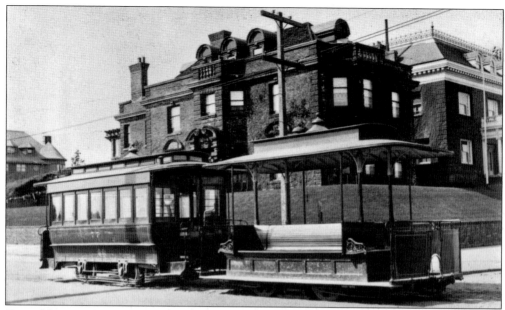

Two cable cars are shown here: the enclosed cable car was actually a dummy car that carried the grip and two sets of brakes, thereby acting as a locomotive for pulling the next car that held the passengers, and the open car made for the easy entry and exit of its passengers. The house in the background, located at 2800 Pacific Avenue, was designed by Ernest Coxhead in 1899 for Sarah Spooner. Spooner was an art collector originally from Philadelphia. She lived in the house for a few years before Matilda and Herman Shainwald, a real estate broker, purchased the house. Local businessman and politician John McGregor took ownership in 1914, and it stayed in his family until 1967. (Courtesy of Paul Trimble.)

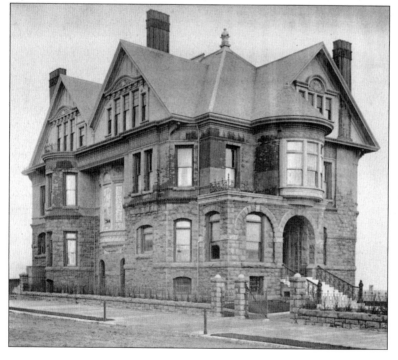

A. D. Moore purchased this home, designed by architect Clinton Day, on the northeast corner of Pacific Avenue and Devisadero (now Divisadero) Street in 1890 for $40,000. In 1893, George and Edith Pope purchased the house for $150,000. Edith Pope eventually divided the lot into four parcels. (Courtesy of the Collection of the San Francisco Architectural Heritage.)

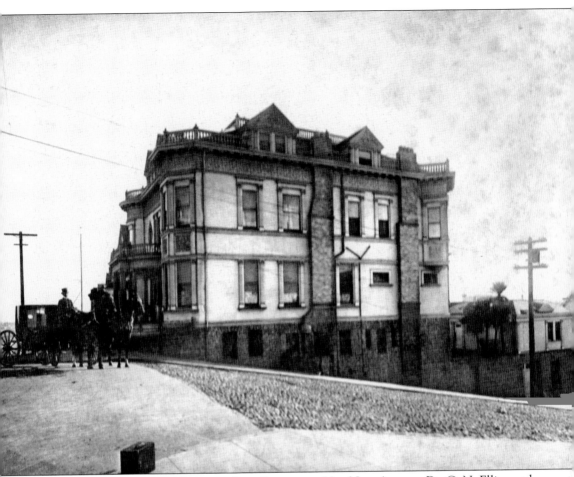

Wanting to move from his home on Pine Street near Van Ness Avenue, Dr. C. N. Ellinwood commissioned architect Eugene Freeman of Smith and Freeman to design this home, first known as 2739 Pacific Avenue and later changed to 2799 Pacific Avenue, a number believed to be better suited for a corner house. The house was under construction from 1893 to 1894, and then the doctor and his wife, Elizabeth, moved in and raised their four children in this house with its 28 rooms, 14 fireplaces, and a glass dome above the center hallway. The family coachman shown in this photograph is Carl S. Anderson, a Swede who was naturalized and in 1900 became a U.S. citizen. During World War II, the FBI stayed at the house to spy on the Russian consulate, who was at Divisadero and Broadway Streets. In 1995, Dr. Ellinwood's granddaughter Anne donated the family's carriage to the San Mateo Historical Society. (Courtesy of Anne Ellinwood.)

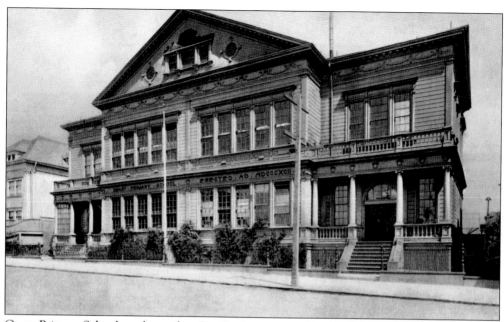

Grant Primary School was located on Pacific Avenue near Broderick Street from 1889 to 1972. It served as the public elementary school for Pacific Heights children. (Courtesy of David Parry.)

Here are the Grant school crossing guards in the early 1940s. (Courtesy of Al Breslauer.)

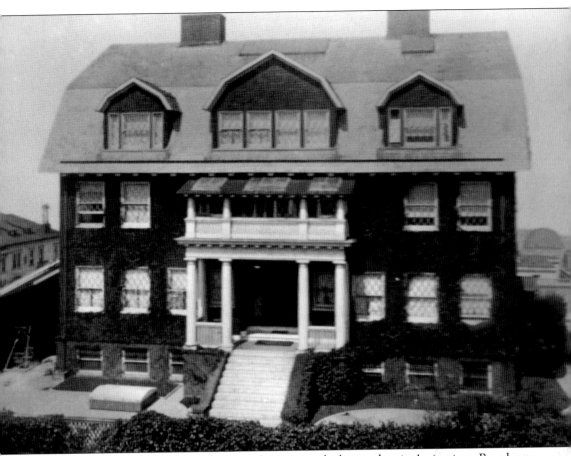

While the address of this house is 2950 Pacific Avenue, the best pedestrian's view is on Broadway Street unless one cares to walk down the long driveway on Pacific Avenue to take a peek at this tucked-away Dutch Colonial–style house. Virginia and Edwin White Newhall had the house built in 1908. Every day, Virginia walked from 2009 Pacific Avenue to check on the house, and if she saw something she did not like, she would change it. The architect finally said to Virginia that she did not need him, so he left; the family has since said that Virginia built the house. The main floor has several large rooms for entertaining, plus a kitchen; there are four bedrooms on the second floor and two bedrooms and three servants' rooms on the third floor. An elevator was added in 1915 when Edwin's father, Henry Mayo Newhall, had a stroke. Originally, Virginia Newhall bought the house in front, located at 2972 Pacific Avenue, for her children to live in, but in 1946, kids playing with matches in the basement started a fire that burned the dining room, so everyone moved into 2950 Broadway Street. Henry Mayo Newhall came to California in 1854 to seek gold but soon found it to be cold, hard, dirty work that did not produce a nugget every day, so he sold his pick and shovel, moved to San Francisco, and went into the auction business. He must have had a good spiel because he started with a small corner and quickly rose through the ranks; when the owners decided it was time to marry the girls, they sold the business to him. From there, he spent his extra money buying a lot of land on those sand dunes that not many had the vision to see would expand into viable neighborhoods. This house is still occupied by a member of the Newhall family. (Courtesy of Jane Newhall.)

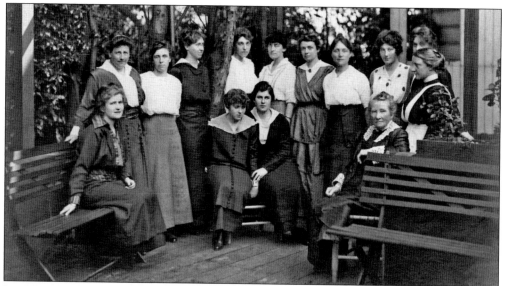

In 1908, Katherine Delmar Burke founded a school at Steiner Street and Pacific Avenue that is no longer there, but shortly after, it moved to 2310 Broderick Street, which is still there and is still the only address on that side of the street. Her mother, Elizabeth "Lizzie" Kennedy, was also an educator. The house had five rooms when the school had only eight or nine students, but as the student body enrollment increased, the family decided to extend the house out to the street line and added rooms in the back. Eventually, they outgrew the house and moved the school to another location. The Burke family kept the home for awhile, and it is still a private residence. This photograph shows the faculty and staff in 1915, from left to right, (seated) Miriam Suplee, Helen Hahone, Marian Regensborger, and Lizzie Kennedy ("Grandma Burke"); (standing) Katherine D. Burke, ? Agar, Clara Dunbrow, Olive Wolf, Helen Kennedy, ? Bowman, Ruth Cox, Clotilde Fahleisen, Florence Pilkington, and Leonie the maid. (Courtesy of Katherine Delmar Burke School.)

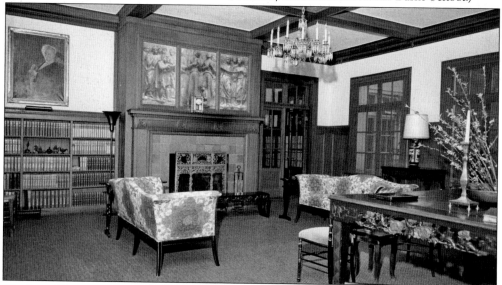

The formal library at the Jackson Street school location was also known as the Red Room. It featured three oversized photographs, which were considered quite unusual at the time, especially the ones photographs hanging over the fireplace. (Courtesy of Katherine Delmar Burke School.)

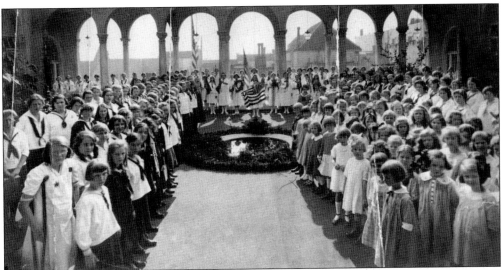

Julia Morgan was a personal friend of Katherine's, so Morgan designed the new school, located at 3065 Jackson Street. Dubbed the House of Dreams, the school opened its doors on January 7, 1918. This 1925 photograph shows students gathered around the pond in the center of the school building. The school educated girls from kindergarten through twelfth grade, with the elementary school moving to Sea Cliff and the high school remaining at Jackson Street until it closed in 1975 and was sold to University High School. (Courtesy of Katherine Delmar Burke School.)

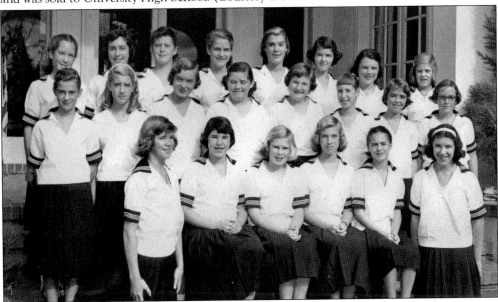

The 1954 seventh-grade class is in front of the Katherine Delmar Burke School, located at 3065 Jackson Street. From left to right, the student are (first row) Heidi McGurin, Susan Smith, Louise Escher, Pris Pillsbury, Susie Bates, and Noel Beardsley; (second row) Ann di Giorgio, Sally Grover, Vera Schottsteadt, Betsy Pease, Randi Hale, Pat Sinton, Nancy Ellis, and Patti Fay; (third row) Perky Stratford, Marjorie Kahn, Patsy Rose, Kathy Maillard, Gloria Campbell, Wendy Harper, Lori Heatley, and Hope Austen. The tuition for grades 6 through 12 was $775, payable in two installments. Fees for physical education, labs, and art supplies ranged from $5 to $20. (Courtesy of Susan Smith Morris.)

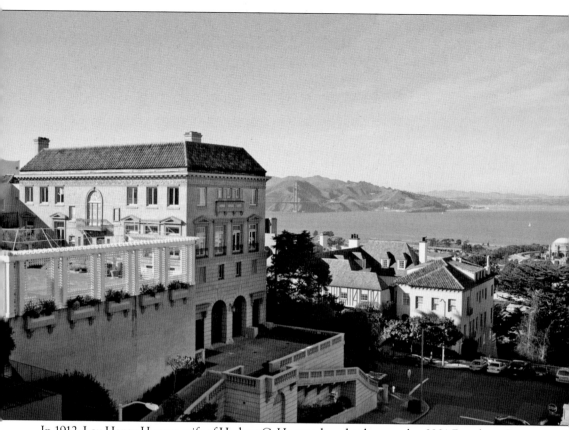

In 1912, Lou Henry Hoover, wife of Herbert C. Hoover, bought the parcel at 2901 Broadway Street from Kate Duer Stoney. Lou sold it to Stanford alumni Milton S. Ray in 1925, who hired architect Henry Clay Smith to build the house. Ray was the vice president, secretary, and treasurer of the W. S. Ray Manufacturing Company, makers of automatic oil burners, ranges, and furnaces. He was also a renowned ornithologist who made numerous discoveries, including the first specimens of gray-crowned lencosticte eggs in 1910. The first fund-raiser thrown at the house was for the Boys Club of America, a club Herbert Hoover founded. Before he passed away, Ray left instructions to call Mitchel L. Mitchell and offer him the house since Mitchell understood the difficulty in building on that site, but one of the terms was that the family be given one year to move the egg collection out of the curio room. Mitchell paid $95,000. Mitchell had a passion for collecting incunabula, which are books printed before 1500. The Mitchells raised their four children in this house. (Courtesy of Dona Crowder.)

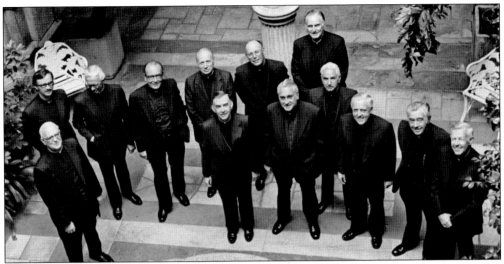

The courtyard of 2840 Broadway Street was originally designed to resemble the atrium in the Spanish Renaissance palace called Casa de Zaporta in Saragossa. The duplication was so exact that when it came time to restore the original palace after it was destroyed in the Spanish civil war, this courtyard was used as a model to aid the restoration workers. This photograph was taken on October 26, 1978, in the atrium of the mansion. Here are (first row) Archbishop John R. Quinn, Fr. Joseph T. Pritchard, Msgr. Francis A. Lacey, Fr. Thomas F. Ahern, Fr. Francis X. Cottrell, and Bishop Francis A. Quinn; (second row) Fr. Alfred Boeddeker (Order of Friars Minor), Fr. Anthony McGuire, Bishop Pierre DuMaine, Fr. Eugene J. Boyle, Msgr. John T. Foudy, Fr. Clement A. Davenport, and Fr. Charles J. Durken. (Courtesy of the Archives for the Archdioceses of San Francisco.)

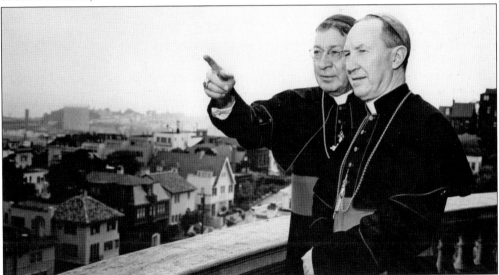

In 1915, Andrew and Julia Welch commissioned Willis Jefferson Polk to design 2840 Broadway Street, and it was completed in 1917. Julia was a devout Catholic and willed the house to the Archdiocese; it became the Archiepiscopal Palace for four decades. This photograph, taken in July 1952, is of Archbishop John Joseph Mitty (left) showing Cardinal Gilroy of Australia the stunning view from the archbishop's mansion. The church sold the mansion in 1979. (Courtesy of the Archives for the Archdioceses of San Francisco.)

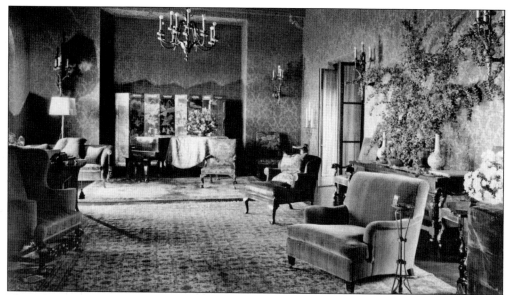

The Schwabacher home, located at 2960 Broadway Street, commonly hosted family, friends, and business guests. May Schwabacher had a passion for practical jokes and was well known at the two stores in town that carried gag items. Unsuspecting guests might find an ice cube with a bug floating in their drink, a fork that would droop rather than scoop their dinner, or a glass that leaned to the left. The home also had a room with a bar in it with a door that was hidden by a fake bookshelf, and while conversing with a guest, May loved to casually lean against it until it fell open. The photograph above shows the formal living room used for guests. (Courtesy of Gail Sokolow Goldyne.)

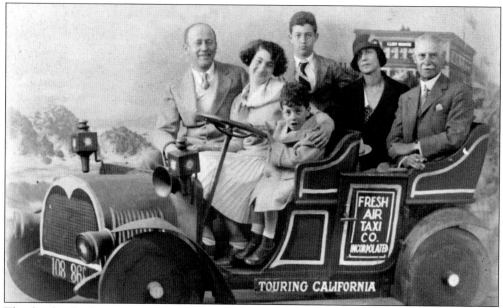

This fun family photograph is of (from left to right) Albert Schwabacher Sr., an investment banker who started Schwabacher and Company; Ethel Schwabacher (Sokolow); Jack Schwabacher; Albert Schwabacher Jr.; May Koshland Schwabacher; and May's father, Joseph Koshland. (Courtesy of Gail Sokolow Goldyne.)

Holidays with this family were always a festive occasion. Gathered for Thanksgiving in 1960 are, from left to right, (first row) Jackson Schwabacher, Trip (Albert III) Schwabacher, and Marty Schwabacher holding Gordon Schwabacher; (second row) Albert Schwabacher Sr., May Koshland Schwabacher, Theo Taft Schwabacher, Maharani of Kush Bahir, and Ethel Schwabacher Sokolow holding Susan Schwabacher (Modic); (third row) the Maharajah of Kush Bahir, Jack Schwabacher (father of Jackson and husband of Marty), Anne Sokolow (Levine), Maurice Sokolow, Jane Sokolow, Al Schwabacher Jr. (husband of Theo and father of Susan), and Gail Sokolow (Goldyne). Not pictured is Taffy Schwabacher (Gallagher). Albert Schwabacher Jr. worked as a stockbroker at Schwabacher and Company, the business founded by his father, and later worked at Morgan Stanley. Jack Schwabacher was a rancher who kept his cattle in Wyoming during the summer and in the Central Valley of California in the winter. (Courtesy of Gail Sokolow Goldyne.)

There are no ghosts in this building (above), claims the manager. This hotel sits at 2901 Pacific Avenue. It has welcomed guests for more than 100 years, including Hollywood stars and politicians, as well as family and friends of the neighbors and curious travelers from all over the world. Neighbors used to take their guests to the hotel for tea or a meal when the hotel had its dining room. (Courtesy of a private collection.)

The Goldstein family, patrons of the famous violinist Isaac Stern, built 2839 Pacific Avenue. In 1960, the third owners, who lived there for 15 years, did extensive remodeling. Since then, the house has had several more owners and has again undergone extensive remodeling. (Courtesy of the Fleishhacker family collection.)

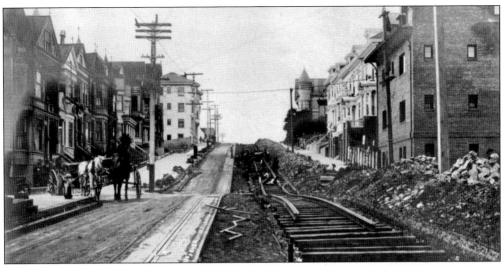

This view is of Jackson Street looking west along Baker Street. The brick building on the right-hand side, 2210 Baker Street, was also known as Bakers Acres. It was a residence club run by Claude Reboul that became popular for single young adults migrating to San Francisco after World War II. The office was on the street level of Jackson Street; the main level had a small living room, a large dining room, and a kitchen. The top floor had rooms for residents. They served breakfast seven days a week and dinner five days a week. (Courtesy of Paul Trimble.)

| MRS. FRANCIS CHAMBERLAIN | | MRS. STUART HEATLEY · |
| MRS. ROBERT DREWS | | MRS. CHARLES POPE |

MRS. GERALD STRATFORD

INVITE

Miss Susan Smith

TO BECOME A MEMBER OF

Mr. Frank Kitchens'

Monday 5:00 o'clock Dancing Class

to be held in the Studio at 3043 Clay Street

MONDAY AFTERNOONS 5:00 UNTIL 6:00 — OCTOBER 5 THROUGH MARCH 22

MEMBERSHIP $45.00 FOR THE SEASON
ATTACHED ACCEPTANCE ACCOMPANIED
BY CHECK MUST BE RECEIVED BY
MR. KITCHENS BEFORE SEPTEMBER 20TH

FOR FURTHER INFORMATION
TELEPHONE MR. FRANK KITCHENS
FILLMORE 6-1830
BETWEEN 10:00 AND 6:00

Many of the young ladies and gentlemen of the neighborhood went to dancing school during their junior high school years. Frank Kitchens ran a popular dancing school at 3043 Clay Street. Students learned basic ballroom dancing to prepare them for social events to come. (Courtesy of Susan Smith Morris.)

The Church of New Jerusalem, the Swedenborgian Church located at the corner of Lyon and Washington Streets, is a national landmark. It was designed in 1895 by a group of pioneers, including painter William Keith, naturalist John Muir, architect A. Page Brown, draftsman/architect Bernard Maybeck, and Rev. Joseph Worcester, and it is believed that the wood for the roof supports came from madrone trees in Santa Cruz cut by Reverend Worcester in order to carry out Maybeck's idea of having madrone arches to support the ceiling. The circular stained-glass window shows a dove at a fountain. In 2004, the church became a national landmark. (Courtesy of Robert W. Bowen.)

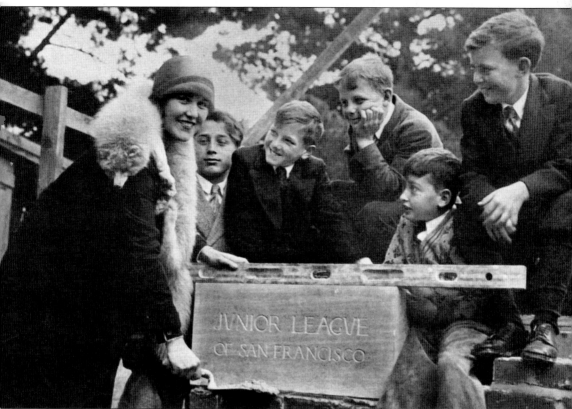

For five and a half years in the 1920s, the Junior League used 2008 Lyon Street as a home for children in need of temporary housing and care. Sent by the Associate Charities, many of these children were either physically or mentally handicapped, and proper care was not available at their own homes. Some children only stayed a few days and others for many months. The Junior League of San Francisco was founded in 1911. Mrs. Bancroft Towne was in charge of the Junior League committee for the home, and a Miss Bubser was the matron of the house. This photograph shows Mrs. Howard Park, president of the Junior League, and some of the boys from the Junior League home at the laying of the cornerstone for the new house, located at Thirtieth and Wawona Streets. (Courtesy of the Junior League of San Francisco.)

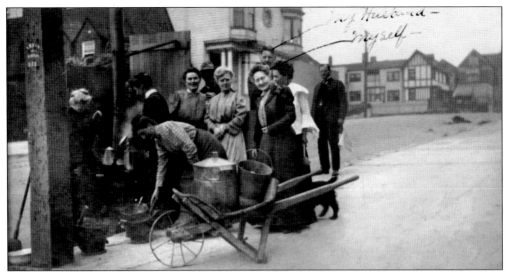

Here are Mr. and Mrs. Charles J. Colley and neighbors in front of their home, located at 3166 Washington Street, right after the 1906 earthquake. They had no water for two weeks and had to use a wheelbarrow to transport fresh water home everyday. Architects Charles J. Colley and Emil S. Lemme designed the Sutro Baths and the second Cliff House. From 1910 to 1914, Colley and the Rousseau brothers were designing numerous residential hotels and apartment buildings in the area between California and O'Farrell Streets and Larkin Street and Van Ness Avenue. Colley designed other buildings, including the Alta Casa Apartments, which once stood at the corner of California and Powell Streets. (Courtesy of David Parry.)

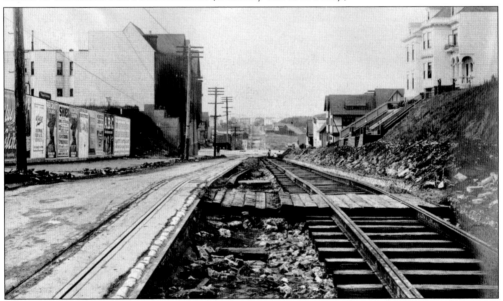

This photograph of Jackson and Lyon Streets looking west was taken in 1906. Some of the billboards along the fence advertise items such as Blue Label Ketchup, Sherman Clay and Company, Recruit Cigars, shoes, and the Republican state ticket, in which the candidates and winners were Gov. James N. Gillett and Lt. Gov. Warren R. Porter. While the sign may not be too visible in this photograph, the empty lot has a $100 for sale sign. (Photograph by John Henry "Harry" Mentz; courtesy of Paul Trimble.)

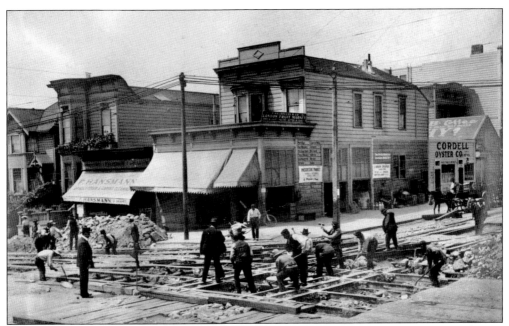

Men are working hard to make way for public transportation for Pacific Heights residents on the corner of Sacramento and Divisadero Streets on July 26, 1906. This corner touted signs directing people to J. Pisani's Progressive Market; F. Baldocchi and Company; the London Fruit Market, where one could purchase wine and liquors, poultry, butter, and eggs; the Cordell Oyster Company; F. Hansmann Upholstery and Carpet Cleaning; and the Larkin Creamery. (Courtesy of Paul Trimble.)

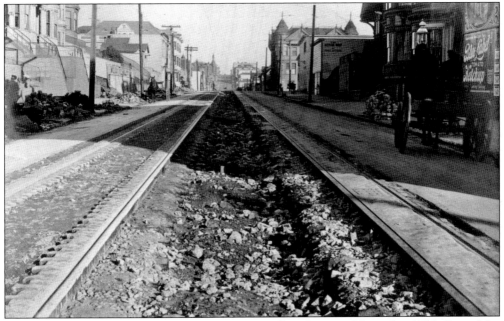

This photograph shows Sacramento Street at Divisadero Street in November 1906. One of the buildings has an advertisement for the Repair Shop painted on it, stating "We Repair Anything." (Courtesy of Paul Trimble.)

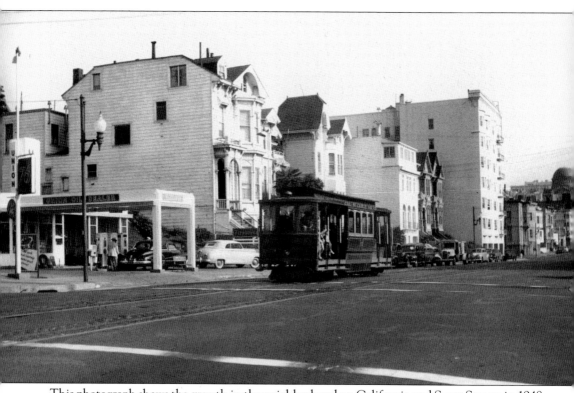

This photograph shows the growth in the neighborhood on California and Scott Streets in 1948. (Courtesy of Jack Tillmany.)

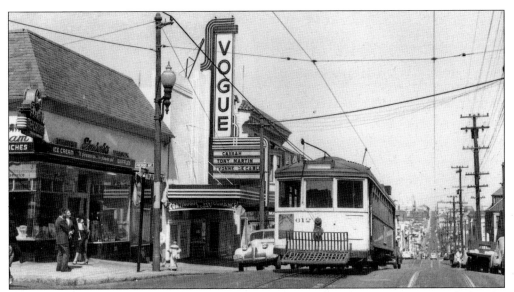

Sacramento Street between Presidio Avenue and Lyon Street was and still is a busy block. The Vogue Theatre, the Gilt Edge Market, and the liquor store, to name a few, were frequent stops for the locals. (Courtesy of Paul Trimble.)

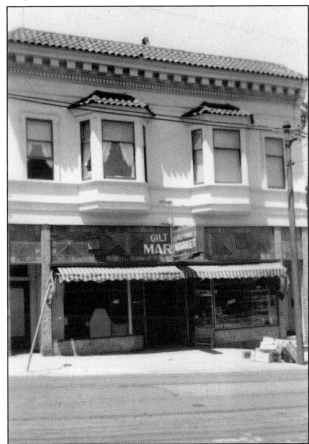

Shown around 1924, the Gilt Edge Market, located on Sacramento Street, was owned by Joseph Dito and two of his sons. It was where many in the neighborhood shopped, and the store would even deliver. (Courtesy of Corinna Metcalf.)

Taken in 1918, this photograph is believed to be the work of a traveling photographer, which was common at the time. The photograph was found in the backyard of 3239–3241 Sacramento Street when the property was being retrofitted in 2000. (Courtesy of Lana Constantini.)

Three

PRESIDIO HEIGHTS

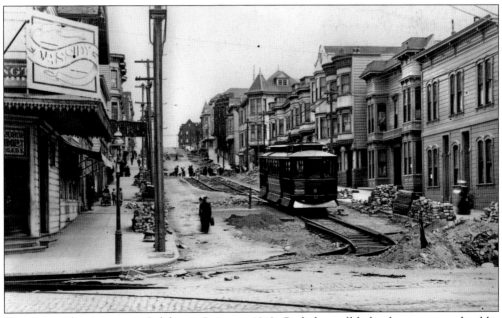

This is Presidio Avenue at California Street in 1910. Gaslights still light the streets, and public transportation was just reaching this outside area. (Courtesy of Jack Tillmany.)

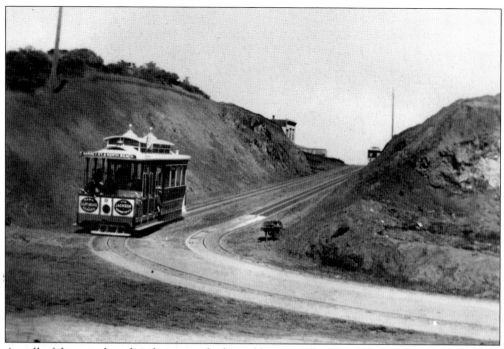

A wall of dirt, sand, and rock surrounds this cable car in the 1890s. By 1906, a new cable line started by United Railroads, running from the Ferry Building to Presidio Avenue and California Street, was in place until 1949, when it was converted to buses. (Courtesy of Paul Trimble.)

Pictured in 1947, cable cars no longer run along this route; now it is Route No. 3. The bus on Jackson and Presidio Streets is shown here going the opposite direction from the cable car in the photograph above. (Courtesy of Corinna Metcalf.)

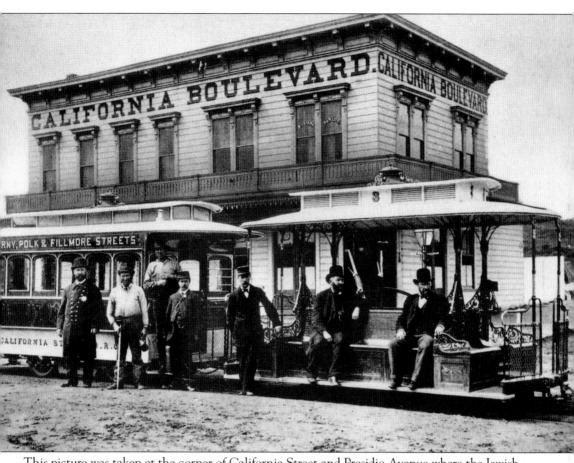

This picture was taken at the corner of California Street and Presidio Avenue where the Jewish Community Center is now. Charles Crocker built the California Street cable car line. The man on the far right is believed to be Leland Stanford. (Courtesy of Paul Trimble.)

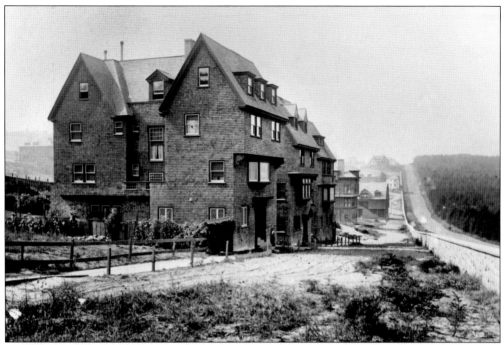

In 1906, the 3300 block of Pacific Avenue between Walnut and Laurel Streets had three shingled homes on it. The roads were not paved, and there was plenty of open space. The popular Julius Kahn playground would eventually occupy the space on the other side of the stone wall. (Courtesy of Caroline Hume.)

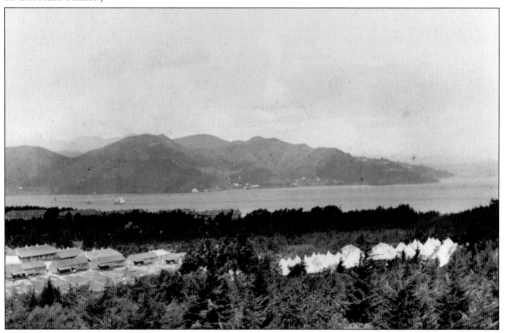

In 1906, this was the view from the 3300 block of Pacific Avenue looking north to the bay pre–Golden Gate Bridge. The army occupied the Presidio, as shown by the tents and a smattering of buildings. (Courtesy of Caroline Hume.)

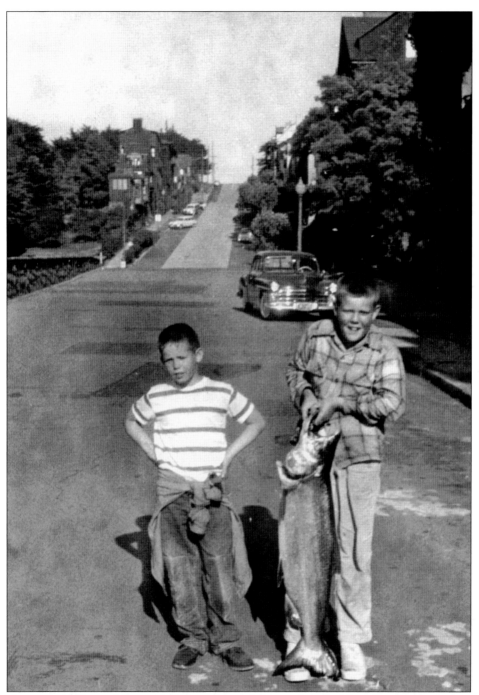

Twelve-year-old George Hume is holding a fish with his unidentified friend on Pacific Avenue in 1958. His parents, Jaquelin "Jack" and Caroline Hume purchased a house here in 1950 and raised their children—Patsy, William, Carol, and George. George now runs his family's business, Basic American Foods, which manufactures dried fruits and vegetables. His father, Jack Hume, and his uncle Bill Hume started the business in 1933 in Vacaville, California. On the next street over are some examples of Ernest Albert Coxhead creations. (Courtesy of Caroline Hume.)

Marie Seligman was thrilled with her new automobile, an anniversary gift. She ran her hat business, Madame Marie, out of her dining room. She learned how to make hats from night school at Galileo and then started her business making gorgeous hats, for which she always seemed to charge less than it cost her to make them. Her husband, Milton Seligman, came to San Francisco from Frankfurt, Germany, in the 1840s at the time of the Gold Rush. Milton and his father later opened banks in the United States, London, and Paris, and his father returned to Germany. As enemy aliens during World War II, the Seligmans were not allowed to go beyond 35 miles from home and were not allowed to go out at night. Marie worked at the USO during the war. (Courtesy of Corinna Metcalf.)

In January 1947, Nick and Corinna Lothar dressed as New World and Old World in celebration of their grandparents Milton and Marie Seligman's golden wedding anniversary. The family got together and bought them a convertible, which they drove down Pacific Avenue with Nick and Corinna's uncle Walter Herbert, then an opera conductor in San Francisco, walking in front of the car blowing a trumpet. Nick and Corinna greeted their grandparents with verses that their mother had written for this day. (Courtesy of Corinna Metcalf.)

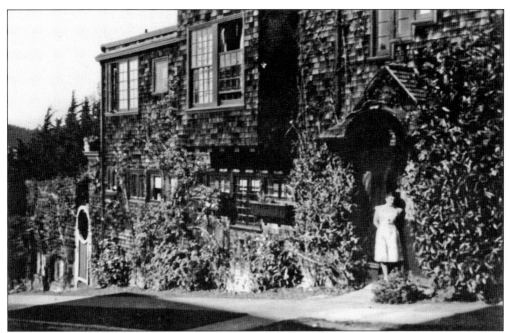

The home located at 3240 Pacific Avenue is the end house on the Presidio wall. The Lothars, Jewish refugees from Germany, lived in the house from 1942 to 1948. The bottom end was so narrow one could touch the front and back walls with arms outstretched. The top end was wide enough for a bedroom and a corridor. Each room was on a different level except for the top floor, where there were two rooms and a bathroom on one level. That top floor was above the lower room of the house next door, where the Gumps lived. One day, the neighbor across the street, criminal lawyer James Martin MacInnis, took his horse up the front steps of his house and into the living room and had a terrible time getting the horse back outside. (Courtesy of Corinna Metcalf.)

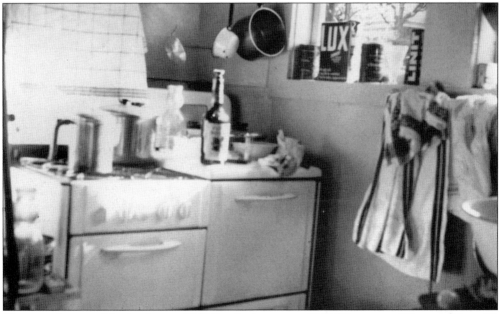

Here is a glimpse of the kitchen at 3240 Pacific Avenue in 1947. (Courtesy of Corinna Metcalf.)

The Sokolow family lived in 3452 Jackson Street from 1943 to 2003. Maurice grew up an orphan in less than desirable conditions, while his wife, Ethel Schwabacher, grew up in luxury. The house and all of its great detailing was a source of great pride for Dr. Sokolow. He was considered the heartbeat of the home, so after he passed away, his daughter Gail created this memory collage. During a remodel by the new owners, Gail was allowed to place her father's stethoscope inside one of the walls so a part of him could continue to be a part of this house. (Both courtesy of Gail Sokolow Goldyne.)

This is Dr. Maurice Sokolow in front of the door to his home at 3452 Jackson Street. Maurice Sokolow was a professor and chief of cardiology at the University of California, San Francisco (UCSF). Maurice's wife, Ethel Sokolow, was an actress who performed on the stage in San Francisco pre-ACT days, raised her children, then returned to acting. She even had a part in Woody Allen's film *Take the Money and Run*. (Courtesy of Gail Sokolow Goldyne.)

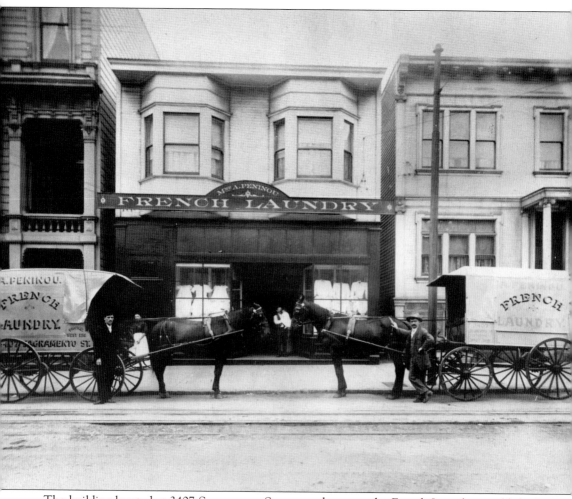

The building located at 3407 Sacramento Street was home to the French Laundry, established in 1903 by A. Peninou. The company is still in business a few blocks away at 3707 Sacramento Street and has expanded to a few other locations as well. (Courtesy of Catherine Grandi.)

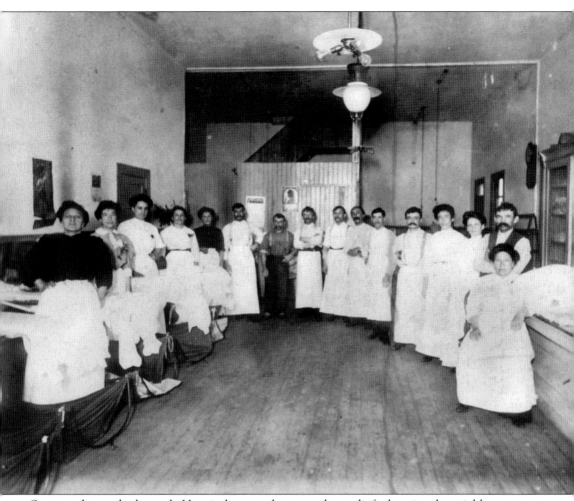

Someone has to do the work. Here is the crew that can take credit for keeping the neighbors neat and tidy. (Courtesy of Catherine Grandi.)

The second family to occupy 3636 Clay Street was the Jones family. Proctor Jones was a photographer, publisher, lawyer, actor, and honorary consul general to Tunisia. One of his books, *At the Dawn of Glasnost*, was presented by Pres. Ronald Reagan to Soviet leader Mikhail Gorbachev as a token of goodwill when they met in Geneva. Pictured here are Proctor and Martha Jones in front of the living room fireplace. (Courtesy of Proctor Jones Jr.)

Armand and Rebecca Weills moved to this house, located at 3601 Clay Street, after they were married in San Luis Obispo in 1885. (Courtesy of David Newman.)

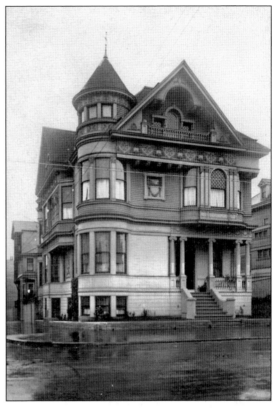

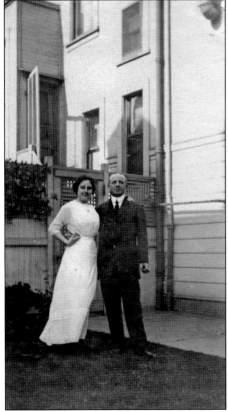

Armand Weill and his daughter Elizabeth Sarah Weill are pictured here. Elizabeth and Edwin S. Newman were married at 3601 Clay Street on February 9, 1913, at high noon. (Courtesy of David Newman.)

This is the south side of the 3600 block of Clay Street. The corner house where the Victorian at 3601 Clay Street once stood is now a much more modern one-level house. (Courtesy of Proctor Jones Jr.)

This is the north side of the 3600 block of Clay Street between Spruce and Locust Streets in the 1940s. This block shows the diverse collection of architecture typical of this neighborhood. (Courtesy of Proctor Jones Jr.)

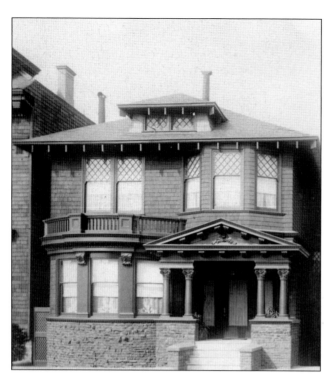

Originally the Auerbach home, 3536 Clay Street still stands today. It still looks basically the same, only taller. (Courtesy of Lynn Bunim.)

CATHRYN AND HAROLD SCHEELINE

BID YOU

TO

COCKTAILS

ON SATURDAY, THE FIRST OF JUNE

FROM FIVE UNTIL SEVEN O'CLOCK

3553 CLAY STREET

Joe Del Valle

LET US HEAR FROM YOU

The neighborhood was very social, and many parties were thrown throughout the year. Clever invitations were part of the fun. Here is an example for a party thrown at 3553 Clay Street between Locust and Laurel Streets. (Courtesy of Barbara Hilp Smith.)

Irma and Joseph Triest pose with their daughter Jane (right) in front of their home, located at 3531 Clay Street, in 1922. Joseph's mother was Sara Haas, part of the Hass Brothers wholesale liquor company, for which Joseph worked. The Haas family also owned a grocery business. Below is a better view of the actual house. (Both courtesy of Lynn Bunim.)

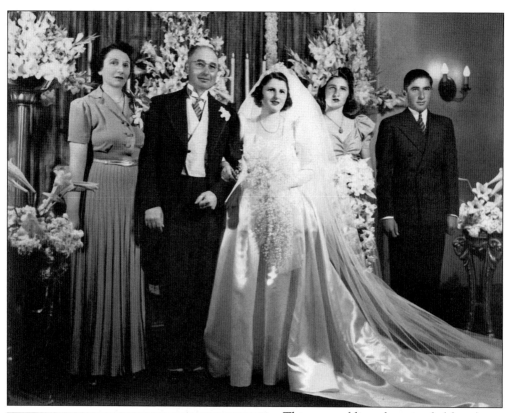

This pre-wedding photograph (above) was taken at 3212 Jackson Street just before Barbara Hilp was to marry Robert H. F. Smith. From left to right are the mother of the bride, Adelaide Wallenberg Hilp; the father of the bride, Harry H. Hilp; the bride, Barbara Pauline Hilp; the sister of the bride, Marjorie Hilp; and the brother of the bride, Harry Hilp Jr. The bride's father, Harry Hilp, was part of Barrett and Hilp, one of the contractors of the Golden Gate Bridge. Adelaide and Harry lived at 139 Cherry Street before moving to this home. (Both courtesy of Barbara Hilp Smith.)

This photograph of Emma Hilp was taken in 1900. Hilp was quite an amazing lady. She was the first woman to serve on the grand jury in San Francisco, and in 1919, one of the cases was the justification for the increase in the price of milk. She was involved with numerous charity organizations, especially those concerning children, such as the living conditions at juvenile court detention centers. She was also president of the Denman Alumnae Association. For a time, she lived at 3295 Clay Street. (Courtesy of Barbara Hilp Smith.)

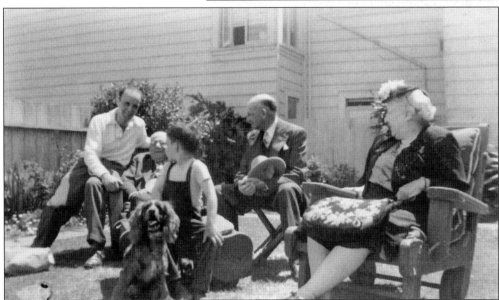

Mark and Aileen Morris purchased 3305 Washington Street in 1939, when it was brand-new, for $12,500 and lived there until 1979. In this photograph, from left to right, are Mark Morris Jr., Mark "Max" Morris Sr., Mark Morris III with his dog Flip, Allie Haines, and Hattie ?. Mark Morris Sr. owned the Western Poster Company, which distributed the movie posters for the front of the movies theaters in Northern California. Allie Haines owned the Summerfield and Haines clothing store at Sixth and Market Streets. (Courtesy of Mark Morris.)

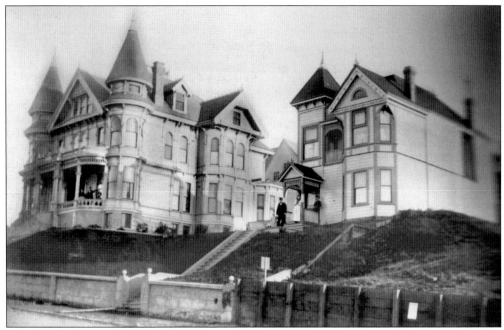

Andrea Sbarboro was an Italian American pioneer. Born in Italy and raised in New York, he arrived in San Francisco in 1852. Sbarboro was a grocer, philanthropist, civic leader, patron of the arts, and one of the earliest Italian bankers in the city, and he also invested in real estate. When purchasing land for his own home on the corner of Washington and Walnut Streets, shown here, he used $300 from his grocery money to pay for the lot. He believed in and strived to inspire others to live the California dream. (Courtesy of the San Francisco Historical Society.)

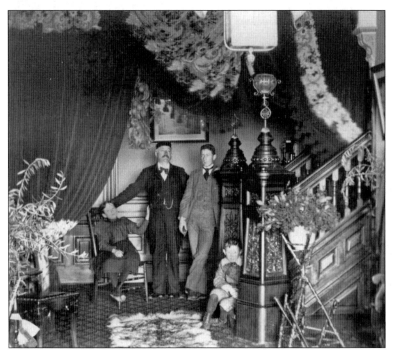

Shown inside the house in 1895 are, from left to right, the youngest Sbarboro daughter, Romilda, named after her mother; Andrea; second son Romolo; and the youngest son, Remo, both named after the founders of ancient Rome. Son Alfred and daughter Aida, named for the opera, are not shown. (Courtesy of the San Francisco Historical Society.)

This is a photograph of Charlotte "Lottie" Judson Levansaler. Charlotte's mother was Ella Doane Judson, and her father, Henry Clay Judson, made dynamite in Potrero Hill. Her husband, James Adams Levansaler, was in insurance, and they invested in real estate, especially in Presidio Heights, so she was destined to do well. She lived at 3398 Washington Street at the corner of Walnut Street. Other members of the Judson family lived throughout the neighborhood, including at 3636 Clay Street. (Courtesy of Charles Ferguson.)

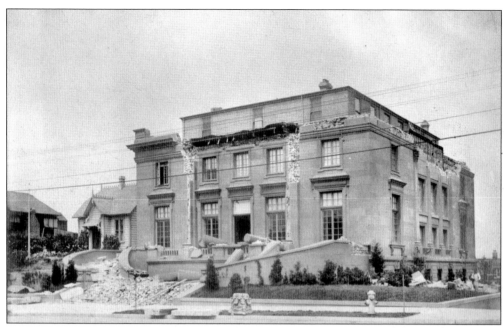

Simon Koshland made his fortune as a wholesale merchant in wool, hides, and fur, and had seven children. Simon's oldest son, Joseph ("Joey"), lived in Boston because this was the shipping point for the New England wool mills. The wool was purchased by Simon and Joey from the West and marketed in the East. Marcus Koshland was the only family member who stayed in San Francisco, where he built this house. (Courtesy of Paul Trimble.)

In honour of
Miss Peggy Sloss

Mrs. Marcus S. Koshland

requests the pleasure of your company
at a Dance
on Tuesday evening, the twenty-eighth of December
at half after nine o'clock
Thirty-eight hundred Washington Street
San Francisco

Butterfly Headdress

Dick Koshland

Many parties were thrown throughout the years at this house; here is an invitation to a dance honoring one of the family members. Guests were asked to wear butterfly headdresses. (Courtesy of Barbara Hilp Smith.)

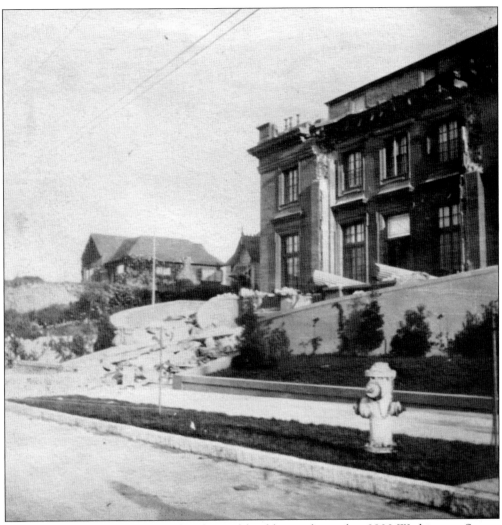

The day after the 1906 earthquake, the Koshland house, located at 3800 Washington Street, was still standing, minus some of its ornamentation. While honeymooning, Marcus and Corinne (Schweiter) Koshland went to Versailles; as they were looking at the Petit Trianon, one turned to the other and said, "When we get back, let's build a house like this." And they did. Architect Frank Van Trees started the project in 1902, and in 1904, a Marie Antoinette costume ball was thrown as a housewarming party. The house has 22 rooms and Bruce Porter stained-glass windows. Many years later, when the Koshlands moved to another home, the house sat vacant for many years because they did not want anyone in it. In 1955, Walter and Elizabeth Buck purchased the home and lived there for 22 years. From 1977 to 1982, the house had several owners until construction company owner Charles Pankow and his business partner, Heide Van Doren, purchased the home. New owners are once again in the home. The house is a San Francisco as well as a national landmark. (Courtesy of Barbara Hilp Smith.)

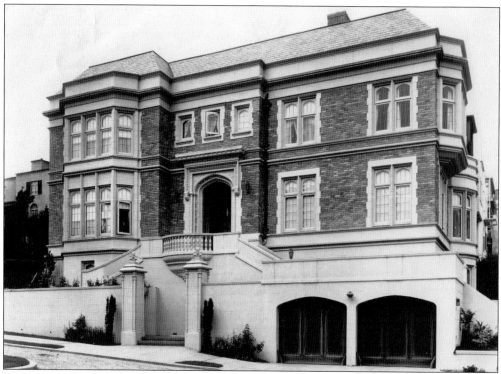

Edwin Newman contracted architect George Applegarth to build this house at 1 Maple Street. Edwin was the second oldest of five children. He managed Crown Army Shirts, a company that manufactured army shirts during World War I. He later joined the Charles Brown and Sons store. (Courtesy of David Newman.)

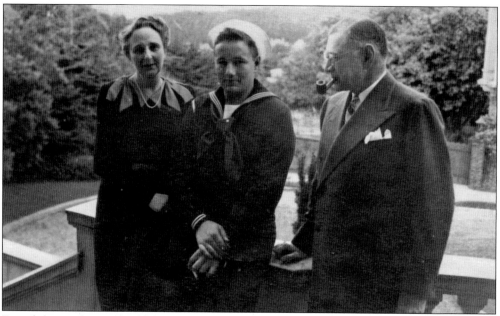

From left to right are Elizabeth, Peter, and Edwin S. Newman at their home, located at 1 Maple Street. The house was sold by 1945. (Courtesy of David Newman.)

Architect George Adrian Applegarth was born in Oakland, California, in 1875. He studied drawing under Bernard Maybeck, attended the Ecole des Beaux-Arts in Paris, and did graduate work in New York with the firm of Barney and Chapman. He returned to San Francisco in 1906 and worked for L. B. Dutton; shortly after that, he partnered with Kenneth MacDonald. Between 1907 and 1912, they built many commercial and residential buildings around town. One of the most famous homes he built was the one located at 2080 Washington Street, built for Adolph and Alma Spreckles. In 1916, the Spreckleses commissioned him to build the Palace of the Legion of Honor, which they donated to the city to use as a museum for European art. That same year, he built his new wife, Gwendolyn, shown here with George, her wedding present—2775 Vallejo Street. (Courtesy of Mary Applegarth.)

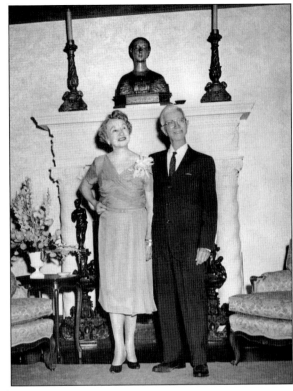

Happy New Year!

Donald Bibbero and Alan Newman

invite you to spend New Year's Eve

in

"Hollywood"

at

ONE MAPLE STREET, CORNER JACKSON

nine to twelve-thirty

Please respond to
One Maple Street

Come as your favorite
Movie Star

Here is an invite to a New Year's Eve party held at the home at 1 Maple Street. The theme was Hollywood, and guests were requested to come as their favorite movie star. (Courtesy of Barbara Hilp Smith.)

Isadore Zellerbach was considered the brains behind the family's paper business. The company was first called Anthony Zellerbach and Son, later Sons, until 1928, when they merged with another company to become Crown Zellerbach, the second largest paper manufacturing company. In 1986, Crown Zellerbach ceased to exist. Isadore was also involved with the Red Cross and was a ballet patron. (Courtesy of Stephen Zellerbach.)

Jenny Baruh was the wife of Isadore Zellerbach and mother to J. D. (James David), Harold Linel, and Claire (Seroni). They lived in a flat on Washington Street between Locust and Laurel Streets before moving to Jackson Street between Spruce and Locust Streets. (Courtesy of Stephen Zellerbach.)

J. D. Zellerbach was the chairman of Crown Zellerbach and the ambassador to Italy during the Eisenhower years. He and his wife, Hanah, lived in a French townhouse–style house in Pacific Heights. (Courtesy of Stephen Zellerbach.)

Pictured here is Harold Linel Zellerbach, who also worked in the family business at Crown Zellerbach and was a patron of the ballet. (Courtesy of Stephen Zellerbach.)

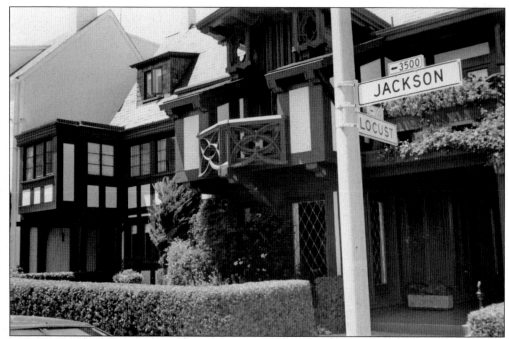

Built in 1909, this house originally extended down Locust Street all the way to Pacific Avenue with a lovely garden behind the house. The garage used to have a turntable so cars never had to back out of the driveway. The Roos house, located at 3500 Jackson Street, is a San Francisco landmark. (Courtesy of the Roos family collection.)

Elizabeth Meyerfeld was only 19 when she married Leon Lazare Roos, but she knew what she wanted. When given a house as her wedding gift by her father, Morris Meyerfeld, owner of the Orpheum Theatre Company, she asked him if Bernard Maybeck could please be the architect. The cost was $36,000, and the result was a true masterpiece, inside and out. (Courtesy of the Roos family collection.)

Maybeck designed much of the furniture in this home as well. The initials "LLR" in a family crest designed for Leon Lazare Roos, owner of Roos department store, can be found throughout the home, from the front door to the screen in front of the fireplace, as well as on the sides of chairs. At one time, original Napoleonic flags tattered from battle hung in the living room. This photograph shows a portion of the living room, including the massive fireplace that still holds the large metal cooking pot. (Courtesy of the Roos family collection.)

Joe and Estelle Joseph bought the flats at 3879 Jackson Street, built them themselves with no architect, and lived upstairs. Estelle's sister Mabel lived around the corner with her children, Fritzie and Leslie, so they played with their cousin Evelyn quite often. This photograph was taken in January 1917 on the apartment steps. Pictured from left to right are (first row) Fritzie Baer, Helen Joseph, Leslie Baer, Doris Goodday, and Evelyn Joseph. Standing above them is George Goodday. (Courtesy of Evy Speigelman.)

Clay Street Park is a wonderful neighborhood playground nestled among apartment buildings and homes on Clay Street between Laurel and Walnut Streets. Young Lynn Burrows enjoys playing on the slide. (Courtesy of Lynn Bunim.)

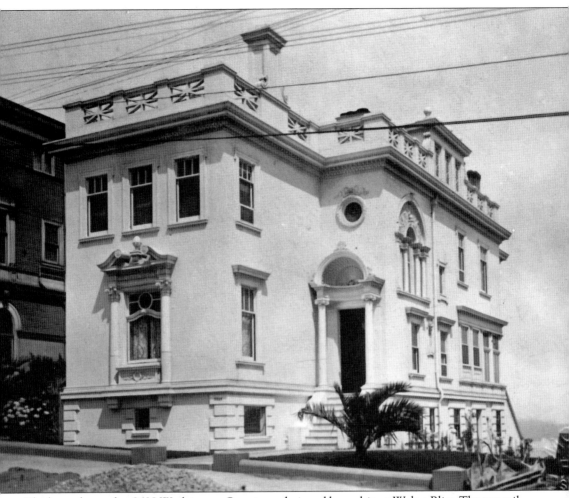

The home located at 3638 Washington Street was designed by architect Walter Bliss. The top rail is no longer in place, and there is an extra side room and garage on the right side of the house now. The cartouche and oeil-de-boeuf window are still in place. (Courtesy of David Parry.)

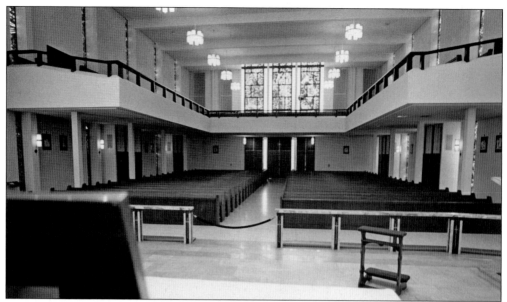

St. Edward the Confessor Catholic Church once stood at 3318 California Street. The interior of the church was primarily marble, walnut, stained glass, and concrete. There are baptism, marriage, and death records for parishioners dating back to 1916. (Courtesy of the Archives for the Archdioceses of San Francisco.)

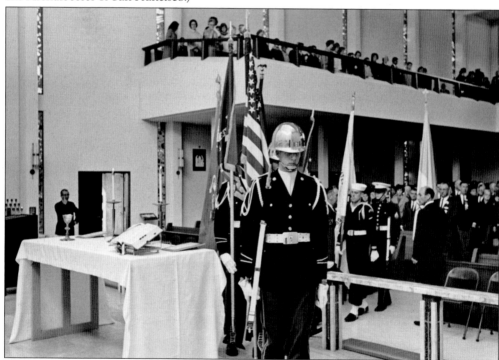

In November 1963, St. Edward the Confessor Catholic Church held a Mass honoring Pres. John F. Kennedy. This photograph shows the color guard bringing the service colors to the sanctuary. Dignitaries in attendance included Mayor John Shelley and his children and Sheriff Matthew Carberry. (Courtesy of the Archives for the Archdioceses of San Francisco.)

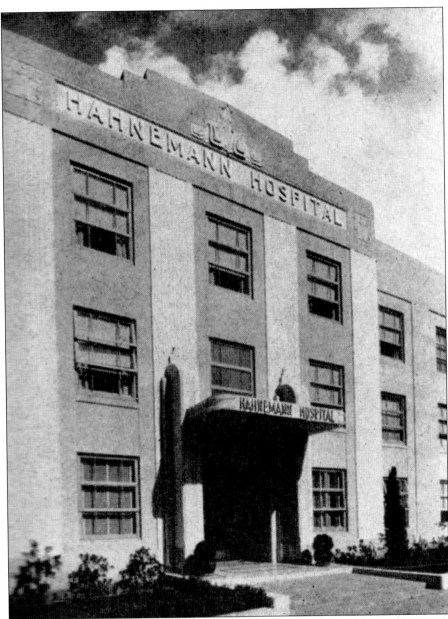

Hahneman Hospital, located at 3698 California Street, was founded on May 25, 1905. It did not actually open its doors until 1906. A 140-bed homeopathic hospital, this modern facility offered its patients and their guests the best services available at the time. It also offered a three-year nursing course and boasted that the results were the best of the best in skilled and attentive nursing care. When it first opened, a bed in a small ward cost $17.50 per week. In 1916, the University of California Medical School took over the management and operation of the hospital and agreed to offer homeopathic classes at its medical school. In 1943, the Hahneman Hospital name returned, and it was touted as offering the latest and greatest equipment and facilities for doctors and patients. The telephone number was Bayview 9321. It was later named Marshall Hale and eventually became the California Pacific Medical Society. (Courtesy of the *San Francisco Medicine Magazine*.)

The Katherine Delmar Burke School Girl Scout Troop, led by Ursula Stratford, would have their meetings at the Stratford home located at 30 Presidio Avenue. Shown on May 28 in either 1954 or 1955 are, from left to right, Kathy Mailliard, Patsy Rose, Louise Escher, Patricia "Perky" Stratford, and Susan Smith. (Courtesy of Mark Morris.)

Shown here are four neighborhood lifelong friends. Harry Hilp Jr. (with tilted army hat) lived on Jackson Street at Presidio Avenue; Jack Euphrat, an ensign in the navy; Peter Newman, an enlisted man in net tending for submarines; and Walter Newman, a lieutenant in the U.S. Army infantry all lived on Jackson Street. Jack's family owned the Pacific Can Company; Harry's father was one of San Francisco's largest construction contractors and helped build the Golden Gate Bridge. Peter lived at 1 Maple Street. He was a principal in Crown Army Shirt Company, which made army shirts in World War I. (Courtesy of Walter Newman and David Newman.)

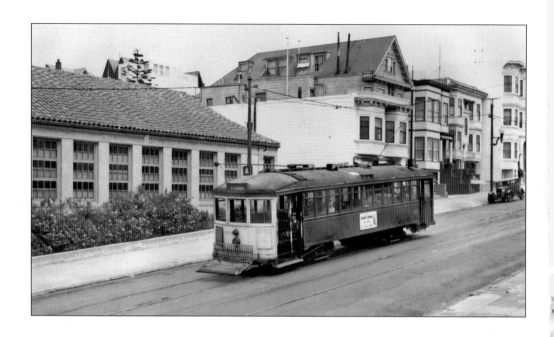

Madison School was the public elementary school for the Presidio Heights neighborhood children. After school, the candy store across the street on Sacramento Street and the Julius Kahn playground were the popular hangout spots for the students. Below is a class photograph taken in 1916. (Both courtesy of Evy Speigelman.)

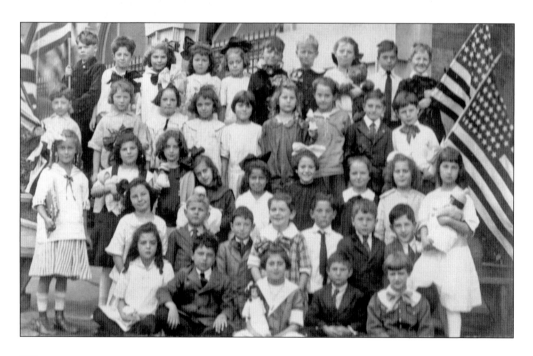

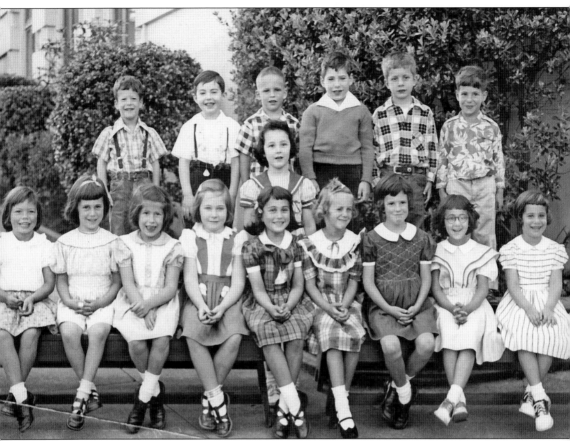

For the Madison School high kindergarten class of 1952, a Miss Barry was the teacher. Some of the neighborhood children who walked to school together are as follows: (first row, far left) K. C. Cookson; (first row, third from left) Katie McLenegan, who lived at 3675 Clay Street; (first row, seventh from left) Elizabeth "Bebbie" Dalton, who lived at 3633 Clay Street; and (first row, far right) Lynn Burrows, who lived at 3641 Clay Street. The boy in the top row at far left is Peter Lilienthal, who lived on Spruce Street. (Courtesy of Lynn Bunim.)

ACROSS AMERICA, PEOPLE ARE DISCOVERING
SOMETHING WONDERFUL. *THEIR HERITAGE.*

Arcadia Publishing is the leading local history publisher in the United States. With more than 4,000 titles in print and hundreds of new titles released every year, Arcadia has extensive specialized experience chronicling the history of communities and celebrating America's hidden stories, bringing to life the people, places, and events from the past. To discover the history of other communities across the nation, please visit:

www.arcadiapublishing.com

Customized search tools allow you to find regional history books about the town where you grew up, the cities where your friends and family live, the town where your parents met, or even that retirement spot you've been dreaming about.